predicting
the weather
by the moon

predicting
the weather
by the moon

Ken Ring

First published 2000.
This edition published in 2000 by Gothic Image Publications, PO Box 2568,
Glastonbury, Somerset BA6 8XR, England

ISBN 0 906362 52 0

A CIP catalogue record for this book is available from the British Library.

Book design by Working Ideas, Christchurch, New Zealand.
Cover design adapted and changed from the NZ version by Nigel White of RWS Design, Glastonbury.

Printed by Hackman Printers Ltd., Cambrian Ind. Park, Clydach Vale, Tonypandy,
Rhondda, Wales CF40 2XX, United Kingdom.

contents

brief glossary

Term	Meaning	Weather
Apogee	Moon farthest from Earth for this month	Light winds, settled conditions
Cold Front	Cold air advancing, pushing away warm air	Changeable
Depression	Area of low (barometric) pressure	
Northern declination	Moon farthest north for month over northern hemisphere	Likely unsettled weather particularly in southern hemisphere
Perigee	Moon closest to Earth for this month	Spells trouble
Ridge of high pressure	Edge of anticyclone	Good weather coming
Southern declination	Moon farthest south for month over southern hemisphere	Likely unsettled weather particularly in northern hemisphere
Stationary Front	Slow-moving weather system	No change for two or three days

acknowledgements

Foremostly I want to extend my gratitude to Harry and Dulcie Alcock for their willingness to devote to me their time, patience and generosity. Thanks also to Philip English of the *New Zealand Herald*, who kicked it all off when he agreed to publish my articles, and suggested I write this book. I am also appreciative of Darren Greenwood (*Northland Times*), Cliff Ashby (*Rodney Times*), Brian Burmester (*Pakuranga Times*), Karen Mangnall (*Western Leader*), Dianne Smith (*Groundspread Magazine*), John Izbicki (*The Independent Newspaper*) and other periodicals and papers since, who have agreed to publicise my weather work through syndicated monthly forecasts and interest articles.

Special thanks too for their invaluable feedback and suggestions, to Richard Webster, Mary Crockett, and Peter Garland (New Zealand); Michael Farnhill (Australia); Tony McGinn, Carl Mathews and Nina Jones (UK); and Mary Coleman, Paul Rohacek and Ronald Thompson (USA).

For their faith in the project and for becoming the driving force towards publication, I am indebted to Quentin Wilson and Antoinette Wilson of Hazard Press in New Zealand and to Frances and Jamie of Gothic Image Publications (UK).

Last but by no means least; thanks to all who have written articles and books that I have been able to refer to (listed in the Bibliography).

my journey

I can remember at the age of three riding my tricycle and noticing the Moon moving with me. I stopped, and it did, too. Then I saw the Moon racing across the sky, behind scattered clouds. My three-year-old brain couldn't work out why it was speeding and getting nowhere.

The first word my infant son Keri uttered was 'Moo', because he couldn't say 'Moon'. It's conceivable that he said it only to shut me up, because I would constantly point to it and repeat the word, assuming he was interested.

During the ten years between 1970 and 1980, we as a family lived in a mobile home, making our way slowly around the North Island of New Zealand. Our lifestyle became one of subsistence because we were continually in remote parts of the country, far from towns and shops. We found people living off the land for survival. There was the drover, the swaggie, the poor farmer, the hippy (which we were taken for), and the gypsy. The culture of the traveller is today romanticised by the house-truckers, but in those days there were no monthly craft fairs, no network of cellphones, and one had to contend with isolation, but the richness of the characters we came across made up for that. A never-ending line of elderly folk shared with us their knowledge about

fishing, medicines from native plants, and food available from the wild.

The set fishing net was out every day. We camped on the coast, especially off-season when all the holidaymakers and their noisy boats had gone home. I ran my net twice a day, because many fish can see the net in moonlight and won't go into it. Nor can they reverse away, because fish don't swim backwards, especially against a current. So they would often stay poised a foot or so from the mesh, waiting for the tide to turn. Wading into the sea I might see half a dozen fish in the net already and two or three waiting. By splashing the water behind them, I could get them to dive into the net and become entangled. I would do this day in and day out, all year around.

This would often get me out of bed at two or three in the morning, wading into the tide, even in the middle of winter. It could be cold, certainly, but the cold didn't occur to me. After all, I had a job to do. I would afterwards get back into a lovely warm bed with freezing feet, which did not impress my wife.

It was in our interest to find out from the locals what fish were running, coming up rivers to spawn at a particular time of year, and where the good spots were. Often we would get misinformation, but you could generally detect this because the narrator would tell you one thing and then do another when he thought you weren't watching.

I had to refer to tide tables, because I always set the net at low tide. I also had to refer to planting guides.

Why planting guides? It was all to do with the drovers. They moved on horseback, unshaven, silent figures in oilskins, towing packhorses behind, and surrounded by ever-moving yelping dogs. These hardy souls 'drove' cattle from out-of-the-way places to the major saleyards and abattoirs. You would see them coming miles away, hundreds of animals moving slowly, stopping to graze, holding up motorised traffic and leaving messy roads as they went through villages and small towns. The bigger towns had special bypass roads for them, signposted 'Stock Route'.

The drovers 'planted out'. They carried little germinating seedlings

with them in springtime, which they put in the ground so that when they came by that way again, they could reap a harvest. Although they had no land of their own, they chose areas that were hidden from view: the back of a disused rubbish dump, the downside bank of a newly formed bridge approach, or the top area on both sides of where a new road cut through a former hill.

In this way, here and there the drovers established little growing patches. All were out of sight from the main road and were unknowingly fertilised by local farmers. The drovers grew things that took care of themselves: pumpkins, butternuts, potatoes, beans.

Once we learned what they were doing – and it was in their interest to tell us so that we didn't pinch theirs – we started doing it ourselves. We therefore had to know when to plant.

My wife and I acquired old planting calendars from second-hand bookshops. Then we started noticing that the Maori fishing timetable and the planting calendar often seemed to match. Both were based on the perigee–apogee cycles of the Moon. It turned out that you fished and planted mainly on the apogee, whatever that was.

I wanted to discover the reasoning behind these calendars. It seemed to me that planting and fishing depended on the climate, which meant weather, so whatever caused heavy seas, strong winds and rain must be very patterned. Was there a link, and, if so, could a system of prediction be devised that covered a whole year? What did the old sages know, and how did they get their information?

I knew I had to start collecting records. I had already studied the cloud patterns and could roughly 'read' the sky. It is easier in the country – your eye travels along the line of the hills and then upwards, a restful and natural thing to want to do, whereas in the city the houses on the skyline seem to scramble the visual transition and discourage the eye from looking up. Perhaps it's just that in the town we don't have to look up because we prefer to pay forecasters to do it for us.

I obtained cloud information from a book in the library. Much of it seemed to work. But I wanted to know more. So I invested in all manner of weather-reading equipment: barometer, temperature gauge, wind

velocity gauge, weathervane, rain gauge, and hygrometer (for measuring humidity).

In a diary I kept a daily record of air pressure, wind speed, air temperature, humidity, Moon phases, and the weather that was just above me. I figured that if there was a universal system it would work above me as well as anywhere else. After all, gravity works on everything at once, so why shouldn't it also apply to the wind, the Moon, and the tides? Newton didn't have to go all over the world dropping apples.

I had to have a scale of weather conditions, and I could not avoid a subjective one. I decided on 13 different weather states and allotted them each a number value:

1 Clear day, fine weather, blue sky, no wind
2 Relatively clear day, slight cloud, occasional breeze
3 Quite thick cloud, a bit blowy, blue sky poking through
4 Overcast, no blue patches
5 Cold conditions, windy, slight drizzle (not real rain)
6 Rain, very intermittent
7 Unpleasant continual drizzle, not much wind
8 Rain plus wind
9 Wind howling, intensity varying, not so much rain
10 Lashing wind and rain
11 Non-stop wind and rain
12 Severe storm, buckets of water, can't go outside
13 Electrical hurricane.

On my scale, rain kicked in at number 6.

I kept this diary discipline for four whole years, every day my first task in the morning and last task before bed, and I 'averaged' what the day could be described as. This I entered with the other data. At the end of the first year I graphed it out, my weather values up the vertical axis, plotted against all other variables along parallel horizontal axes.

It came as a big surprise to me that the only factors coinciding with a weather value reading exceeding 6 were the full and perigee

phases of the Moon. All other factors seemed to have no consistent relevance. Sometimes it rained when it was cold, sometimes when it was warm. Wind speed and humidity similarly showed no pattern.

By the end of the second year I could see the pattern repeating and began to predict weather for myself and my close friends. I had made up a perigee stick like the ones the Maori elders used and was using it until I realised you could simply refer to a nautical almanac to find out when the next perigee was coming. Of course, you can always see when the full Moon is there.

The basic rules were:

- If it was full Moon, guaranteed rain or change
- Same if it was perigee, with gusty winds as well
- If perigee and full Moon occurred on the same day, a double lot of bad weather
- If perigee and full Moon occurred a few days apart, the bad weather hung over those days.

That was basically it at that time. After four years I had identified a real pattern purely from my own observation, but I knew that it must be only the tip of the iceberg. Clearly a small piece of a pattern wouldn't sit in the middle of a random process: it all had to be patterned. I made up my mind to investigate what the perigee really meant in physical terms, and to find out all I could about the Moon's phases. Because I had identified the full Moon and perigee first, I surmised that those two factors controlled the pattern. It turned out that even back then I wasn't far from the nub of the situation.

No one, except my wife Jude, believed me. A group of us were all set to travel to Nambassa, the rock music festival. I noticed from the almanac that the full Moon and the perigee were due to coincide just before the festival and so I said don't go, it will pour down. But they all went anyway – without me. And as I thought would happen, a torrential downpour meant that most campers got thoroughly washed out on the last day of the event.

The Sydney-to-Hobart yacht race was held, I think, the next year.

It had maximum media coverage in my country, as many of our finest and most experienced yachtsmen and women were taking part. A violent storm at sea turned what started as an exciting race into a catastrophe. Six boats went down, including one named the *Spirit of Enterprise*, the pride of the New Zealand fleet. I looked up the tables. Sure enough, full Moon on the same day as the perigee, a few days before the race.

I was sure I had found out something that maybe others ought to know about. So I took my data into the observatory in Auckland to see if it was known to climatologists, and if so why yacht races were held at such daft times of the year. I was told, politely, that my work wasn't scientific enough, and the information was not new. They weren't interested, not even in seeing my collected data.

Then I rang the TV news weather office. Their response? 'We know all that stuff.' I said, 'If you know it, why don't you tell the people?' 'Oh,' they said, 'we're not here to educate.' I disagreed. 'You are so! If I knew of some danger and I didn't tell, I could be locked up!'

I reasoned that public information gatherers like media have an ongoing responsibility to pass on vital information, especially to yachtsmen if they know the weather is going to get bad. But I am sure they are not unkind people: the truth is that they just don't know. Only a handful of researchers and long-range forecasters bother to investigate the lunar link to the weather. Perhaps this is because everyone who is supposed to know these things, the meteorologists, say the Moon doesn't affect the weather, so that's that. Because no one questions it there seems little need in most people's minds to investigate the matter.

So whenever I went into libraries or bookshops, there was only one subject on my mind. But I found very little written on the subject. There are lots of books about weather, but when I turned to their indexes for the word 'Moon', I generally found either no reference at all, or passing descriptions of spring and neap tides. Only here and there was there any suggestion that the Moon influenced weather, let alone

controlled it. On TV and radio and in newspaper forecasts the Moon was, as to this day, never mentioned. What was going on?

Occasionally I got a break. I stumbled on a book called *Guide to the Moon*, by Patrick Moore. In those pages I read for the first time about atmospheric tides. Then I was given a Time-Life publication simply called *Weather*, which also described the patterned behaviour of the atmosphere. One could read between the lines and see that a whole alternative theory was in there, somewhere, and that much of what the Moon was actually responsible for was being ignored. How did the tide of the atmosphere relate to the tide of the sea? I had already noticed that the weather changed with the changes in the sea tide, so knew there was some connection.

Once, I went to the library and looked up all the weather-related disasters in New Zealand's history that I could think of, and matched them against the Moon phases nearest those dates, to see if any pattern emerged. Amazingly, almost all the weather-related disasters happened in the same week of either the full Moon/new Moon and/or coinciding with the perigee. One particular book, a government publication called *Floods of New Zealand,* made it very easy for me by listing all the country's floods and heavy rainfalls between 1917 and 1953. Out of some 700 events, I found that 80 per cent were Moon-cycle related. Another 15 per cent were too, only I didn't know it then because they were at declination points, which I was not then considering.

I then felt I had enough to present to the print media. I approached the *New Zealand Herald* and they printed a full-page article (by chief reporter, Philip English), based on what I supplied. I was very appreciative, and in the days following I was contacted by people who either currently used the Moon phases themselves or could tell me what their grandparents did, in terms of weather prediction, fishing and planting. So I wrote out the perigees for the next year and put Philip a little more in the picture. He was enthusiastic and started noticing them for himself. It was his suggestion that I write this book.

By this time I had acquired access to the Internet. So I put out a call to climate centres around the world, places with names like the Alaska

Climate Research Center. My question was always the same. Can anyone tell me of any links between the Moon and the weather? Replies ranged from 'Absolutely, yes,' to 'There may be a link but it hasn't been established,' to 'Sorry, no link at all.' But I *knew* there was a link. I had proved it time and again with my own records. I could scarcely believe that the scientific community were that much in the dark, and even divided over it. Yet who was I? Even my own local observatory had denied it. But by now I was surfing the Internet like crazy, and discovering many and varied conference papers by NASA scientists and other alternative meteorologists and forecasters like Richard Holle, confirming and adding to what I had been seeking, thinking and saying for all those years. Clearly, in some scientific circles a controversy raged on the matter, but it hadn't reached the shores of my country, and to this day still hasn't been the subject of any media discussion or public debate.

In 1998 they held another Sydney-to-Hobart yacht race. They held it again at the time of the perigee. Sixty-seven of the boats turned around and limped back. Some were lost without trace. Six lives were lost. I contacted the *New Zealand Herald* again and Philip ran another story on my lunar theories. Then, out of the blue, I got a call from Harry Alcock.

Harry said he had been following my articles and had been meaning to write to me for two years. Had I heard of him? I said no. Not surprising, he responded. He had written a book ten years previously and had been forecasting seasonal weather for farmers on a subscription basis for 30 years. A former umbrella manufacturer, he had needed to know what the weather was going to be in the weeks following, so he wouldn't waste money on advertising if the week was going to be rain-free. He had therefore embarked on a personal quest for weather knowledge, using trial and error, and studying old texts, until he came up with a reliable system. Meteorologists had given him a hard time, stopping his book's publicity with a quick response of their own; and when he syndicated to newspapers they bullied those papers and questioned his credibility. Harry told me I was on the right track but that there was much more he could probably tell me.

Harry was now 80 and nominally retired from his forecasting. He sent me his little book. I couldn't wait to meet him and travelled down-country to visit within days. His wealth of knowledge on the subject is tremendous. Before he rang me, he had written a letter to the editor of the same newspaper:

> Your article on Ken Ring (January 18) and his reference to the Moon influencing the weather is correct. It would also seem that depressions will predominate near the dates he mentions, when the Moon is at perigee and also close to the full Moon, up to November anyway. The depressions will all be either over New Zealand or about the south of the country...

Meeting Harry was a godsend. To this day I remain very grateful to the Alcocks for lending me books, articles, and their carefully saved newspaper clippings dating back many decades.

Those are roughly the events leading up to this point, where I am fulfilling a dream started 30 years ago, that I might some day come up with a workable system for foretelling weather.

It is a long time since I was three years of age, yet the Moon still holds the same fascination for me. It has inspired poets, lovers and dreamers for thousands of years. And now this book.

the formation of the moon

There are three theories about how the Moon came to be in place:

- the Moon came from the Earth
- the Moon was captured by the Earth
- the Earth and Moon were formed together.

The first theory postulates that the Moon was once part of a larger planet Earth. It states that after a massive planetary explosion, the Moon was torn away from Earth (possibly from the region that is now the Pacific Ocean).

The second theory is that the Moon was once in orbit around the Sun, between Mars and Earth. Some 2500 million years ago the Moon came close enough to Earth to be captured by Earth's gravity. This caused a mighty disturbance, resulting in a mutual orbit around a common centre of gravity.

The third possibility, that the Moon and Earth were formed separately out of an initial cloud of gas and dust, is the current theory. Much weight and credence is given to the fact that both Earth and Moon seem to be the same age. It seems that the solar nebula, the beginning of moons-to-be (called proto-moons), draw material to themselves from the cloud of gas and dust around them. Because of

the extreme cold of space, this theory seems to explain the many icy moons around giant planets in the outer solar system.

The temperature difference that plays a role in the formation of the planets seems also to play a role in the formation of their moons. Just as the planets became more and more icy the further from the Sun, moons seem to be more and more icy the further from the planet they orbit. For example, Jupiter's moon Io (close to Jupiter) is very rocky, but Europa (farther from Jupiter) has more ice, Ganymede and Callisto (farther still from Jupiter) have lots more ice.

By whatever means it came to be in place, as Earth's Moon finished forming, about four billion years ago, the surface was hit by the remains of boulders that are thought to have formed the Earth. During this time the Moon warmed and experienced volcanism. There is abundant evidence of volcanic plains from this time period. Towards the end of the period of bombardment by boulders, scientists think that the Moon was hit by a series of very large boulders, these collisions forming what we know today as the Lunar Maria.

Has the Moon a molten core? Because of its small size, the Moon would have cooled very rapidly compared with the Earth. Soon, the Moon would have cooled completely to the form we see today. Surface activity such as plate tectonics ceased once the Moon cooled. Even the interior of the Moon seems to have cooled to the form of relatively tiny molten activity, no more than 725 km (450 miles) in diameter.

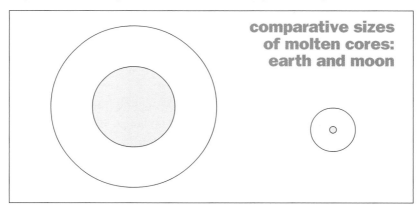

comparative sizes
of molten cores:
earth and moon

With no atmosphere and no magnetic field, the Moon's surface is exposed directly to the solar wind, which is the electromagnetic field of energy encompassing the Sun. In its four-billion-year lifetime many hydrogen ions from the solar wind have become deeply embedded in the Moon's surface. Rich in hydrogen, they may one day provide fuel to run lunar-based factories.

The Moon has a crust, about 60–150 km (35–95 miles) thick. The interior composition of a moon can be guessed from density measurements and also determined more exactly from spacecraft navigation data when a spacecraft passes by or goes into orbit around a planet or moon. The density of iron is about 5 g/cm^3. The density of silicate rock is about 3 g/cm^3. The density of the Earth's Moon is about 3.3g/cm^3. This density is close to that of silicate rock, suggesting that the Moon has a large mantle made mostly of rock.

There is an old joke about two astronauts who staggered out of a pub on the Moon, declaring it had no atmosphere. In decades past it was accepted that moons such as the Earth's Moon or the moons of Jupiter were airless bodies with no atmosphere. Now, however, measurements have shown that most of these moons, including our own, are surrounded by a thin atmospheric region of molecules.

The atmosphere may come from the release of gases such as nitrogen, carbon dioxide, carbon monoxide and radon, which originate deep within the Moon's interior. Another source are molecules which are loosened from the surface when bombarded by other molecules from space. These molecules may migrate across the surface of the Moon to colder regions, where they recondense into the ground, or they may fly off into space. This mechanism is a source of water and helium. Is there lunar water?

In decades past it was accepted that the Moon contained no water. Moon rocks collected by *Apollo* astronauts (at lunar equatorial regions) contained no traces of water. Lunar mapping performed by the orbiting *Galileo* spacecraft at coarse resolution also found no traces of water. But the more recent *Clementine* mission made measurements which suggested that small, frozen pockets of water ice may be embedded in

shadowed regions of the lunar crust. Although the pockets are thought to be small, the overall amount of water might be quite significant. This water may come from comets, which may continually bombard the Moon, or water in the form of molecules that migrate to the coldest regions of the Moon, where they refreeze on the surface, trapped inside enormous craters – some 2200 km (1400 miles) across and nearly 13 km (8 miles) deep – at the lunar poles.

Because of the very slight tilt of the Moon's axis, only 1.5 degrees, some of these deep craters never receive any light from the Sun – they are permanently shadowed. This means that the frozen water must remain there, otherwise energy from sunlight would split much of this water into its constituent elements, hydrogen and oxygen, both of which would fly off into space immediately.

how **large** and **far** is it?

The Moon is unusually large. Its diameter is 3476 km (2163 miles), compared with 12,756 km (7927 miles) for the mean diameter of Earth. The Earth is three and a half to four times bigger than the Moon and 81 times as massive (as heavy) as the Moon. For our solar system this is an extremely high ratio, compared with the planet it orbits. (Pluto's moon Charon is a notable exception.) For instance, the nearest comparison is that of Neptune's moon Triton, which is only one two-hundred-and-ninetieth of Neptune's mass.

There is consequently an unusually large gravitational attraction operating between Moon and Earth. That is why it has such a gravitational effect on everything that moves freely – its pull is about two and a half times that of the Sun. When the Moon is closer or brighter, this attraction is increased.

The Moon is 384,400 km (about 238,000 miles) away from Earth. This is almost ten times the distance around our Earth. If it could traverse space, a train speeding at 100 km/h (65 mph) would take about five months to get there. If the Earth were the size of a basketball, the Moon would be the size of a tennis ball.

Space is called 'space' because there's so much space there. Hold a peppercorn between your index finger and thumb. Imagine it is the Earth. The Moon would be a pinhead an inch away. What is the proportional distance to Alpha Centauri, our nearest star neighbour? Well, you would have to catch a plane to Singapore and stand in that city holding another peppercorn! Astronauts who flew to the Moon were struck by how the Earth and Moon seemed tiny specks in an infinite, empty void. So large are the voids separating celestial bodies that most illustrations exaggerate the size of the objects to avoid rendering them as almost-invisible dots.

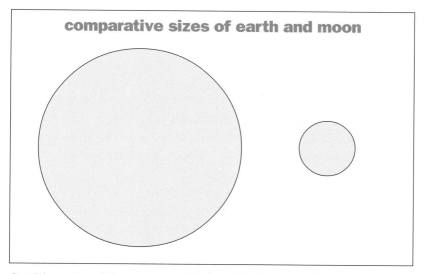

comparative sizes of earth and moon

On this scale, all human spaceflight with the exception of the *Apollo* lunar missions has been confined to a region of two pixels surrounding the Earth. Seeing the Moon's orbit in its true scale brings home how extraordinary an undertaking the *Apollo* project was. Of all the human beings who have lived on Earth since the origin of our species, only a handful have ventured outside that thin shell surrounding our home planet. Even the orbit that geosynchronous communications satellites occupy is only a little more than a tenth of the way to the Moon.

The Earth is a planet, revolving around the Sun once in a year, and

the Moon is a satellite, revolving around the Earth at about 3700 km/h (2300 mph) in just less than a month. If you were on the Moon you would have days and nights, but each day and each night would be two weeks long.

The Moon moves rapidly with respect to the background stars. It moves about 13 degrees (26 times its apparent diameter) in 24 hours (slightly greater than its own diameter in one hour).

This rapid motion has given it a unique role in the history of astronomy. For thousands of years it has been used as the basis for calendars. Isaac Newton got crucial information from the Moon's motion around the Earth for the law of gravity.

Almost everyone has noted that we see the same face of the Moon all of the time. It's the 'Man in the Moon' that children are enthralled by. One thing this shows us is that the Moon turns exactly once on its axis each time that it goes around the Earth. The pull of the Earth over millions of years has caused the Moon, which once rotated by itself, to be now relatively orbit-free, in what we see as a face-to-face dance of the Earth and Moon. It drifts eastward with respect to the background stars (or it lags behind the stars). It returns to the same position with respect to the background stars every 27.323 days.

Half a billion years ago the Moon lay closer to the Earth in its orbit, and it has been moving away into the beyond of outer space ever since, at the rate of about an inch per year. As the Moon recedes, our month increases by about a second every 4000 years. We know from fossil records of rock formation that 350 million years ago the month was a day and a half shorter, making for closer to 13 months in the year rather than 12. There seems to be general agreement that at one stage, thousands of millions of years ago, the Moon was closer to us than it is today, perhaps as little as 20,000 km (12,000 miles). If so, then the month, or time taken for it to orbit the Earth, would have been a mere 6.5 hours. The tides raised by the two bodies' effect upon each other would have been violent, indeed. Yet the Moon would have suffered more from this proximity. These mutual tides would have slowed down each other's axial rotations and pushed the Moon farther away.

About 500 million years ago the Moon would already have been 320,000 km (200,000 miles) away, still with a bulge towards the Earth which would have kept slowing the Moon's spin. Finally, the Moon would have stopped rotating altogether; its revolution would have been 27.3 days, and the Earth's rotation would have increased to 24 hours.

The process is still continuing, because the Moon's tidal pull on the Earth is still slowing us down. Each day is approximately 0.00000002 seconds longer than the day before. This works out to a gain of one second in a hundred thousand years, which only becomes noticeable when comparing lunar eclipses observed many centuries ago.

Although the Moon is still receding from us it will not keep receding indefinitely. At 560,000 km (350,000 miles) it will start to come in again, due to the tidal effects brought by the Sun, and then it will be broken up eventually by the Earth's gravitational pull. It will end as a swarm of orbiting particles around Earth in a system of rings like those of Saturn. We would no longer have tides, except one big one permanently aimed towards the Sun. Life on Earth would be impossible because there would only be atmosphere on the Sun side of the Earth. There would be no water; just one big stationary cloud.

But wait – that wouldn't happen. It would take 30,000 million years for the Moon to come that close. And 25,000 million years previously, due to changes in the Sun, the Earth/Moon system will have ceased to exist.

the moon in ancient times

Mesopotamia is a fertile plain enriched by silt from the Tigris and Euphrates rivers, in the Middle East. Today the territory is occupied by Iraq and Kuwait. It was here that, about 5000 years ago, people known as the Sumerians created the world's first truly urban society in the city-states of Ur and Urak.

Ur was one of the first large settlements to be established in the area and became one of the most prosperous Sumerian city states. Numerous annual and monthly festivals were held in Ur, including a monthly feast to celebrate the first sighting of the new Moon. In the eyes of the Sumerians, each month began with the emergence of the new Moon in the heavens and ended with its disappearance at the next new Moon. The months were about 30 days long, with the first quarter occurring on the seventh day, and the full Moon on the fifteenth. This resulted in 12 months or moon cycles occurring each year, which resulted in a year of 354 days. They also divided the day into 12 periods and further divided these periods into 30 parts (four minute increments).

As early as 3500 BC the Sumerians constructed four-sided monuments, which acted like sundials. By watching the moving shadows they were able to mark off high noon as well as the solstices and equinoxes. They also erected large observatories or watchtowers in the temple

complexes of the great cities to study celestial phenomena. The biblical Tower of Babel was said to be such a monument.

Ur has been called Abraham's city. According to the Scriptures, Abraham faced serious problems. The Moon worship in the city was considered an abomination to God in some quarters, and, with his father Terah, Abraham left Ur to go to another centre of Moon worship at Haran. After Terah died, Abraham accepted the challenge to go on to the Promised Land of Canaan. Joshua Chapter 24 makes it clear that Terah worshipped false gods. In the pre-Christian era, Moon observance and measurement for weather and harvest prediction generally became systematised as Moon worship.

The fundamental debate between those who believed that the Moon exerted terrestrial influences and those who believed that only a non-celestial God controlled life on earth still persists to this day.

The Sumerians worshipped the Moon god Sin, which, not surprisingly, today is the word that has come to mean the very transgression of moral law. The Latin word *sinister* meant 'left' and was long associated with evil. It was an insult to extend the left hand for a handshake. The older Indo-European root word *es* meant 'all that there is' and 'that which is true'. Among its modern derivations are: is, soothsayer, entity, essence, and present. Etymology is never fixed in stone, and perhaps what was considered abnormal – for example, left-handedness – came to represent a darker side of life, and a Moon symbol (the word sin) became a label for heresy because of the changing religious power structures.

The Ziggurat of Nanna, a temple of worship to Sin, was built in Ur about 2100 BC. Sin had several different names that referred to the Moon's phases. The name 'Sin' itself indicated the crescent Moon (Ceres later became the name of the Roman goddess of agriculture, hence the words crescent, kernel, create and increase); Nanna was the name during full Moon and Asimbabbar meant the beginning of each lunar cycle.

Sin was said to be the descendant of the sky god An and was born from the rape of the grain goddess Ninlil by the air god Enlil. For his crime Enlil was banished by the assembly of the gods to live in the

underworld. When Ninlil realised she was pregnant she decided to follow Enlil to the world of the dead to let him witness the birth of his child. But giving birth in the underworld would have imprisoned the child forever in the kingdom of the dead. As an appeasement, Enlil offered the next three children who were going to be born to the infernal deities. This allowed their first child, Sin, to ascend to the heavens to light the night sky.

This myth related to Sin's birth explains why Sumerians viewed a lunar eclipse as an attack of demons against the Moon. During the lunar eclipse, Sumerian kings would ritually wash themselves, believing these rites could bring the purification of the Moon.

Because the Sun and Moon appear roughly equal in size, they were generally considered in the same creation stories. They were most often depicted as husband and wife and were attributed human emotions such as anger, jealousy and love. The rules of community conduct took their cue from the narrated stories about the behaviour of the Sun and Moon. In many cultures the Sun was the god of life and goodness, and the Moon represented the underworld, presumably because of its association with the powers of darkness.

The Bedouins of Egypt pictured a tale of unfulfilled sexual passion between a boring husband, the Moon, and his hot-blooded wife, the Sun. In a sexual fury the Sun attacked the Moon, which resulted in what we now observe as spots on the Sun and scars on the Moon. Although they went separate ways they still had sexual contact once a month, the result of which was believed to cause the shrinking phases.

Some Central Asian tribes regarded the Moon as the shy one of the pair, who crept up to the sky only when humans were asleep. Sometimes it hid and did not appear at all.

According to North American legend the Moon and Sun, as husband and wife, were once enclosed in a solid stone house, until a worm bored holes so that a gopher could insert fleas. Irritated by the insects the Sun and Moon raced up into the heavens.

Ke'so, the Sun, and his sister, Tipä'ke'so, the Moon ('last-night sun') lived together in a wigwam in the east. The Sun dressed himself to go hunting, took his bow and arrows and left. He was absent such a long time that when his sister came out into the sky to look for her brother she became alarmed. She travelled twenty days looking for the Sun; but finally he returned, bringing with him a bear which he had shot. The Sun's sister still comes up into the sky and travels for twenty days; then she dies, and for four days nothing is seen of her. At the end of that time, however, she returns to life and travels twenty days more.

The Sun is a being like ourselves. Whenever an Indian dreams of him he plucks out his hair and wears an otter skin about his head, over the forehead. This the Indian does because the Sun wears an otter skin about his head.

— Native American folk tale

But in a legend of north-east India, the Moon was a brother lusting for his beautiful sister, the Sun. Both were of equal size and brightness. She repelled his advances by flinging ashes in his face, thus resulting in the cool planet we see today and confirming the universal taboo on incest.

In Greenland the Moon is again a brother, Annigan, who chases his sister, the Sun goddess Malina, across the sky. So intent is he on the chase that he forgets to eat and grows thinner and thinner, eventually stopping to rest. Dropping to Earth he hunts and catches a seal which he eats, then returns once more to the chase. This scenario is enacted month in and month out, explaining the traditional new Moon seal hunt undertaken by the Arctic people.

The 'Man in the Moon' idea exemplifies its masculinity and is wide-spread. In northern Europe, among Lithuanian and Latvian peoples, it was told that the male Moon wedded the Sun, but the Sun rose at dawn leaving the Moon to wander alone, courting the morning star. In anger and jealousy the Sun cleft the Moon with a sword, explaining the diminishment of the phases.

Aborigines of Australia call the Moon 'The Wanderer'. In an ancient

tale, a man was chased off the edge of the world by a dingo (wild dog). When he returned he was so hungry that he gorged himself on possums. The dingo returned, found him and once again gave chase. But the man was now too fat to move, and the dog ate him. When it had finished, it tossed one of the man's arm bones in the sky, where it became the Moon-man.

Rongo was the name of the Moon god in Babylonia; and curiously, in pre-European New Zealand and Hawaii it was also known by that name. Rongo was believed to control nature and act as a fertilising agency, causing winds and crops to flourish.

The Moon has always been the symbol of fertility. In prehistoric times people made rock drawings matching crescent Moons to the horn shapes of known animals. The ram's horn became an important religious symbol, just as crushed horn persists today in Asia as an aphrodisiac. An awareness of the 28-day regularity of the lunar cycle can be seen in cave markings in Spain, which date back to 7000 BC. Any rituals associated with crops, rain, success in battle or courtship were held on the new Moon or full Moon.

Festivals in some cultures, such as the Roman, were numerous. A Moon watcher was employed to sit on a hill and blow a trumpet at the first sign of the new Moon. This appeared as a very thin crescent, shortly after sunset, on the western horizon. Only then could the times of the month's festivals be set down. The Roman *calends* actually meant the day of the new Moon, the first day of the month; on that very day it was publicly announced on what days the nones and ides of the month would fall. Even today in isolated parts of the Middle East the month begins with the actual observation of the first crescent. Astronomers of old were delegated to stand on a high place and peer low into the west at dusk to spy the visible signal that would indicate they did not need to add a thirtieth or a thirty-first day to the present month but instead could wipe the slate clean and begin the cycle again with day one. Imagine the difficulties we would have today paying rent, collecting debts and meeting deadlines if such a system had persisted.

As each Moon phase took approximately seven days to complete,

the number seven was considered the most mystical. Seven days formed a week, and there were the seven celestial bodies, seven colours in the rainbow, and seven notes to the musical octave before the pitch starts to repeat. High tides become low every seven days, then high again to high water mark almost exactly 14 days later.

Tides were viewed not only in the oceans but menstrually and in life and death as well. It was observed that life ebbed and flowed, and the Moon was believed to play a big role in human death. For ancient Persians, Indians, Greeks, Arctic people and some African tribes, the Moon was a stopping place for departed souls on their way to heaven. As it waxed each month, increasing in size, some souls, unable to find room, were sent back to Earth for reincarnation. The crescent shape was seen as a boat carrying souls. For ancient Egyptians, heavily dependent on the Nile for food, water and transport, the crescent Moon-shaped boat became a symbol of life's journeying.

Where a female Moon was fertile, a male Moon was lustful; either way, sexuality was implied. It was widely believed that young women risked pregnancy just by staring at the Moon or lying naked in the moonlight. The concept of fertility in crops, birth and rebirth eventually gave the Moon its status of femininity.

In ancient Greece, lunar fertility cults sprang up, headed by high priestesses. Lunar, a relatively minor Roman goddess, became an all-powerful deity when the Roman Empire expanded into Europe and the Middle East, bringing together diverse traditions of Moon worship. Lunar became the personified goddess of the Moon. Later she is identified as the Roman goddess of nature, fertility and childbirth.

Hecate (the Moon goddess of ancient Thrace) is the Greek goddess of the crossroads. She is most often depicted as having three heads – one of a dog, one of a snake and one of a horse – and she is usually seen with two ghost hounds that were said to serve her. Hecate is most often perceived as the goddess of witchcraft or evil, but she did perform some deeds worthy of credit. One was when she rescued Persephone (daughter of Demeter, the queen of the Underworld and the maiden of spring) from the Underworld. Hecate is said to haunt a three-way

crossroad, each of her heads facing in a certain direction. She is said to appear when the ebony Moon shines.

In east Asia, too, the Moon loomed large in mythology. The earliest Chinese calendar was based on lunar cycles, with observations of both the Sun and the Moon. The twenty-eight divisions of the Chinese lunar year were called *Hsiu*, 'Houses', and each House was inhabited by a warrior-consort of the Moon goddess. Such a calendar was also used in Japan, Korea, and Vietnam.

The belief is that long ago the Earth was in a state of havoc because there were ten suns in the sky, and these were the sons of the Jade Emperor. Rivers dried up, the land became barren, and many people died. Seeing the death and destruction caused by his sons, the Jade Emperor took this matter to the god Hou Yi. The Emperor asked Hou Yi to persuade his sons to rise up away from the Earth to end the catastrophe. When Hou asked the suns to leave the sky, they refused. Made angry by their defiance, Hou Yi, a great archer, launched arrows at the suns, shooting them down one by one, until his wife Chang O pleaded with him to save one sun to keep the Earth warm and bright. Knowing that the Jade Emperor was furious at the slaying of his sons, Hou Yi and Chang O were forced to stay on Earth. Chang O was unhappy, so her husband tried to win back her favour by gathering herbs that would give them the power to ascend to heaven once again. Chang O remained angry, however, and ate all the herbs herself. She flew up to the Moon, where she remains alone, living in the Moon Palace.

In a story of patience, Wu Kang, a restless good-for-nothing, decides to become an immortal but cannot stick to lessons from his immortal tutor. Asking to go to a new place, he is taken to the Moon. Once there the tutor instructs Wu to chop down a cassia tree. The cassia tree, if not completely chopped down in one day, reappears whole the next day. As Wu Kang lacked (and still lacks) the patience to finish the job, he is up there chopping still.

To traditional Chinese, the Moon was a timepiece. Being an agricultural people they planted and harvested by the Moon and gave special

attention to the Moon in times of worship. During the Tang Dynasty (AD 618–906) the fifteenth day of the eighth lunar month was made an official holiday, Moon Festival.

In Taiwan, the Harvest or Fruit Moon (full Moon in September) signals a time for romance and family togetherness. The fifteenth day of the eighth lunar month marks the mid-autumn festival, also known as the Chinese Moon Festival. On this special day Chinese people worship in temples throughout Taiwan and hold joyous family reunions at home. After nightfall, entire families go out under the stars for picnics in public parks. It is also a special time for lovers, who sit holding hands on river banks and park benches.

According to folk legend the fifteenth day of the eighth lunar month is also the birthday of the Earth god, Tu-ti Kung. Thus the festival has come to symbolise the fruitful end of a year's hard work in the fields. Farming families across the island express their gratitude to the Earth god, and to heaven, represented by the Moon, for the year's good blessings.

During the Yuan dynasty (AD 1280–1368) China was ruled by the Mongolian people. Descendants of the preceding Sung dynasty (AD 960–1280) were unhappy at submitting to foreign rule and set out to coordinate a rebellion. The leaders of the rebellion, knowing that the Moon Festival was drawing near, ordered the making of special cakes. Baked into each Moon cake was a message with the outline of the attack. On the night of the Moon Festival the rebels successfully attacked and overthrew the government. What followed was the establishment of the Ming dynasty. Today, as a reminder of family unity, round Moon cakes are eaten to commemorate this event.

In agrarian society, festivals mark the passage of time. Lifestyles may have changed in modern Taiwan, but the traditional festivals carried forth from ancient Chinese society remain an important part of family life. There are many legends that claim to be the origin of the festival for celebrating the radiant Moon.

One of the most popular is similar to the legend outlined earlier. It is the story of Hou Yi, an officer and bodyguard of an emperor in the

Hsia Dynasty (2205–1818 BC), and his beautiful wife, Chang O. As the legend goes, Chang O stole from her husband an elixir said to ensure youth and immortality. Upon swallowing the drug, she soared to the Moon, where her youth and beauty were preserved. As punishment for the theft, however, Chang O was doomed to stay in the firmament forever.

Among the most ancient of monuments are the remains of giant stone structures erected by people of the Stone Age in France and many other sites in Europe. There are about 900 megalithic circles in the British Isles alone. They range in height from about 1m to 22 m. There are single standing stones (monoliths), stone circles (consisting of many monoliths) and perfectly aligned rows of monoliths.

The best examples are located near the island town of Carnac, in southern Brittany, France, where there are almost 4000 megaliths arranged in a variety of configurations. They date from about 3500–3000 BC. Long ranges of standing stones seem to be planted strategically in the ground in parallel alignments.

Some have speculated that stones such as these served as astrological systems, Druid temples, calendars or ancient astronomical observatories, and many ascribe a precise astronomical orientation to the alignments. There are also table-like arrangements, dolmens, believed to be funeral monuments, with passageways linking the world of the living with the world of the dead.

Stonehenge, near Salisbury, in southern England, is the most famous of all megalithic monuments. These megaliths were built in three periods, beginning about 3000 BC, and consist of four concentric ranges of stones.

Various archaeologists and astronomers claim that Stonehenge was used to predict eclipses of the Sun and Moon and that the people of this region also observed the Moon's horizon cycle, as well as the Sun's, including the measurement of solstices and celestial phenomena such as the lunar eclipses.

In 1964 Gerald Hawkins, professor of astronomy at Boston

University, subjected the Stonehenge site to numerous tests. He concluded that the Stonehenge architecture acts as a sort of Neolithic computer, used to predict eclipses of the Sun and Moon. Stonehenge astronomers were also counting off eclipse 'seasons' which recur about every six months. The site's axis points roughly in the direction of the sunrise at the summer solstice.

In October of 1999 I was lucky enough to be able to visit Stonehenge for myself. I discovered that whoever the ancient astrologers were who built this masterpiece, they must have been fascinated by the movements of the Moon. It appears they constructed a device that could not only foretell eclipses, measure tides and observe and predict perigees, but also mark out lunar declinations and larger lunar transits. In short, they had not only an astronomical computer that was accurate to within 3.408 hours in 49 years, but also a giant weather calculator. Although the Sun and Moon don't move as far south and north as they did at Stonehenge times, nevertheless the structure would still work today for climate prediction.

Astrologers? Certainly. The ancient astrologers were astronomers. Their very religion seems to have been measurement itself. Four thousand years ago the transit of Venus and Mercury provided them with points of ongoing reference as to how Earth moves along the ecliptic path around the Sun.

The Moon has always been linked numerically to the whole celestial environment. In ancient astronomy there were seven celestial bodies visible to the naked eye, believed to revolve in the heavens about a fixed Earth and among fixed stars. Each in turn was thought to influence human affairs and personalities. These seven bodies were Mercury, Venus, Mars, Jupiter, Saturn and the Sun and the Moon.

But because it is our nearest neighbour in space and makes visible changes day by day, the Moon has fascinated humankind the most. Little wonder that it has been considered responsible for such variances as tides, moods, battles, weather and sexual attraction. Inhabitants of coastal settlements for thousands of years have relied on fishing for survival and needed lunar data for tide variations. It would not have

gone unnoticed that the menstrual cycle, too, is lunar and tidal, tying us (especially women) to the Moon's possible influence. But how did the cycle of the Moon become the cycle of human ovulation?

Being hunter-gatherers, early humans, probably the females, would have had to keep going as long as they could, while there was light, to gather enough food. When they couldn't hunt and gather, which would have been three evenings in the month, what else was there to do? Could this have been the time reserved by the females for mating? It is reasonable to assume that human bodies developed a lunar-related time clock which controlled the secretion of chemicals responsible for the breeding cycle, which became the menstrual cycle. If so, given that the hunter-gatherer period lasted more than a million years, there was time for such a biogenetic rhythm to evolve.

A look at our primate cousins reveals that the menstrual cycle is 28–35 days in most of the other primates as well, especially the great apes (the gorillas, chimpanzees and orangutans). Some, such as the New World and Old World monkeys, have a 30–40 day cycle, but persimians (lemurs, lorises, and tarsiers), the more primitive primates, reproduce only once a year.

By way of comparison, in the rest of the animal kingdom seasonal reasons seem more important than moon phases. The ungulates (giraffes, elephants, antelopes) are all seasonal, as are reptiles. Rodents (rats, rabbits) are flat out all the time. Also, the place where humans evolved was not markedly seasonal, winter and summer in north-east Africa being of no special significance.

All of the evidence collected about non-primates indicates that they mate at certain times because of environmental factors that are due later; spring, for example, producing fresh growth and available food. It is well documented that human female flatmates adjust their menstrual cycles to each other, indicating that the cycle can be changed naturally. This happens in zoo-confined primates as well. The menstrual cycle is indeed a 28-day one, coinciding more with the Moon than if it were a 31-day cycle.

In the Lebembo Mountains bordering Swaziland a small part of a

baboon's thighbone, dating from about 35,000 BC has been discovered with 29 notches engraved on it. It is the earliest known tallying device. Was it a Moon phase counter?

The earliest form of a known lunar calendar consists of notches etched into bones 20,000 years ago by paleolithic tribesmen in central Africa. These notches are arranged in groups of 14, which many believe to have been a record of days measuring the time between full and new Moon. Presumably, it was important to know when the next continuous night light for hunting activities would occur, or possibly when the next mating period could be expected!

In north-western Mexico we find the same type of recording, dating from a much later period of 3000–2000 BC, carved on stone. These lunar calendrical tallies appear alongside lists of weapons and kills.

discovering predictable patterns

The Sumerians are known to have developed writing around 3200 BC, and it is conceivable that their recordings of trade and events also encompassed celestial and climatic data for use in agriculture. In 3500 BC the Egyptian communities, depending on the Nile for their prosperity, used the movements of the stars as a guide to the annual rise and fall of the river as well as the extent of its periodic flooding. In ancient writings we find references to the Moon and, in the same texts, guides to seasonal changes.

In 335 BC the Greek philosopher Aristotle, in his book *On The Heavens,* noted that the Earth had to be a round sphere rather than a round plate because eclipses of the Moon were caused by the Earth coming between the Sun and the Moon. Before him, in 450 BC, Anaxagoras of Clazomenae reasoned that because the Earth's shadow on the Moon is curved, the Earth itself must be spherical. If the Earth had been a flat disc, the shadow would have been elongated and elliptical.

The Athenian 'Tower Of The Four Winds' dates back to the first century BC. An early observatory, it displays on its eight faces carved figures representing the eight winds recognised by Aristotle three centuries earlier. Aristotle had divided winds into two classes, polar

and equatorial, and described with amazing accuracy the weather and the month likely to occur for each.

The most industrious compiler of classical weather lore was Aristotle's pupil Theophrastus. His *Book of Signs,* written about 300 BC, described more than 200 portents of rain, wind and fair weather, and a few that were alleged to reveal what the weather would be like for the coming year or more. As well as introducing cloud folklore ('in the morning mountains, in the evening fountains') he described signs to be found in the behaviour of sheep, the way a lamp burns during a storm (probably due to atmospheric changes), and the crawling of centipedes towards a wall.

He was the first to note that a halo around the Moon signified rain coming. He also claimed that flies bite excessively before a storm. Research shows this to be incorrect – unless they had different flies 2000 years ago. Nevertheless, his book was a major reference work for forecasting for the next 2000 years.

The Roman poet Virgil (70–19 BC), in his agricultural treatise *The Georgics*, said:

> The father himself laid down what the Moon's phases should mean,
> the cue for the south winds dropping.

He also wrote:

> Nor will you be taken in by the trick of a cloudless night
> When first at the new Moon her radiance is returning
> If she should clasp a dark mist within her unclear crescent
> Heavy rain is in store for farmer and fisherman.

Almanac is an Arabic word that means 'calendar of the skies'. When Columbus sailed west 500 years ago – around an Earth he thought was shaped like a modern rugby ball – he, like other sailing captains of his time, had in his possession an early German nautical almanac. Along with the almanac's calendar of movements of the planets, stars and Moon, were instructions about the weather, such as the Moon's

halo preceding rain or snow, high tides meaning storms at sea, and Northern lights heralding cold weather.

Only priests, astrologers and men of authority had access to these ancient texts – the accumulated wisdom of millennia of Persian, Greek, Islamic and European science – until books became more freely available during the fifteenth century, after Gutenberg's invention of movable type for printing.

The almanacs also listed future lunar eclipses. When a Jamaican chief threatened to withhold the food supply to Columbus's hungry and mutinous crew in 1504, the resourceful navigator threatened to remove the Moon permanently. It was the early evening of 1 March and an imminent total lunar eclipse, a fact known only to Columbus. As the Moon started to disappear, the frightened chief, overawed by the mariner's apparent mighty powers, relented. The Moon then reappeared within the hour. They had no further trouble with their food supplies.

Benjamin Franklin, George Washington, Thomas Jefferson, James Madison and John Quincy Adams all kept daily weather records in order to understand (and predict?) the weather.

Since biblical days it has been known that particular months bring particular winds.

> Out of the south cometh the whirlwind.
>> – Book of Job

> When ye see the south wind blow, ye say, There will be heat; and it cometh to pass.
>> – St Luke

And as Bartolomaeus Anglicus, thirteenth-century scholar, observed:

> The North winde... purgeth and cleanseth raine, and driveth away clowdes and mistes, and bringeth in cleerness and faire weather; and againward, for the South winde is hot and moyst, it doth the contrary deedes: for it maketh the aire thicke and troubly, and breedeth darknesse.

Around AD 200 the Greek mathematician, astronomer and geographer Ptolemy, resident in Alexandria, re-examined the old idea that the Earth was stationary and that everything else revolved around it. He concluded that the idea was flawed because, if true, at times the Moon would have to appear twice as big as at other times. That it did *not* was worrisome to Ptolemy.

Ptolemy also described what has come to be known as the 'Moon illusion', in which the Moon hanging low over the horizon looks much bigger than when it is high in the sky. Actually it is the same size. This is not an optical effect but a psychological one.

Simple observation over very long periods was the way old forecasters worked. It was not necessary to understand the mathematics of the orbits. The ancient Egyptians, Chinese and Mayan observers did seem to know about the longer Moon cycles and passed the knowledge on. In this way they were able to plot and plan over several lifetimes for solstices, equinoxes and eclipses. For instance, it was known that eclipses repeat on a cycle of exactly 6585.3 days. We can

traditional names for full moon in the northern hemisphere

January	Old Moon, Moon after Yule (Christmas)
February	Snow Moon, Hunger Moon, Wolf Moon
March	Sap Moon, Crow Moon, Lenten Moon
April	Grass Moon, Egg Moon
May	Planting Moon, Milk Moon
June	Rose Moon, Flower Moon, Strawberry Moon
July	Thunder Moon, Hay Moon
August	Green Corn Moon, Grain Moon
September	Fruit Moon, Harvest Moon
October	Hunter's Moon
November	Frosty Moon, Beaver Moon
December	Moon Before Yule, Long Night Moon

guess that the cycles that were the most useful were those visible and immediately relevant to daily life. The Mayan *tzolkin*, or 260-day cycle, the most important time unit in the Mayan calendar, was probably the nine-Moon (265.7-day) interval between human conception and birth.

When mathematics became involved, it was only partially helpful. Ptolemy and the Greeks knew that the Moon moves around the Earth, but their faith in the purity of numbers, and therefore in the conviction that orbits all had to be circular, which symbolised perfection (thinking that a deity would not have created otherwise), prevented them from realising the true picture of Moon movement. It led to intellectual stagnation on the subject for 1300 years.

Nicolaus Copernicus, a Polish astronomer, published a book in 1543 claiming that the Earth rotates on its axis and, with the other planets in the solar system, revolves around the Sun. This was the birth of modern astronomy, yet even he was stuck on the notion of perfectly circular orbits.

It was left to Johannes Kepler, whose first law, published in 1609, stated that the planets and Moon move around the Sun in ellipses. His second law, published in the same year, stated that the speed of a planet around the Sun depends on its distance. In other words, the nearer the faster. Mercury, which is 57.9 million km (36 million miles) from the Sun, moves much more quickly than Earth at 149.6 million km (93 million miles). Mercury's day is about 25 days long and its year 88 days.

The Moon, too, changes its speed as it comes nearer to Earth and slows as it moves away, all in the space of a month, with sometimes devastating climatic results to the inhabitants of Earth.

The first known map of the Moon was drawn in about 1600 by William Gilbert, physician to Queen Elizabeth I and pioneer investigator of magnetism. From 1609 onwards, Galileo, using telescopes which he built himself, made a whole series of dramatic discoveries of Moon features and orbits.

Suddenly, telescope making was the rage. In 1641 Johann Hevelius, a city councillor of Danzig (in Poland) built an observatory on the roof

of his house and gave names to everything on the Moon he could think of. About half a dozen of his names are still in use. He also printed maps of the Moon, using ink on a copperplate. After his death his maps survived, but the plate got melted down and made into a teapot.

Around this time, as serious scientific observation began, Moon worship started to decline in the Western world, due almost entirely to suppression by the Catholic Church.

Fertility and growth had always been a mystery to early thinkers and writers – hence the Moon, also mysterious, was always thought to be the king of mystery and magic. The catalogue of its lunar powers developed by the Egyptians had been spread by the Greeks and then by the Romans throughout the Western world. When the Roman Empire declined, the ancient writings were saved by Arab scholars, and the Arabs then became the principal sources of magic during the European Renaissance (and hence for modern witchcraft).

The ability of witches to control the fate of other individuals was believed and feared by ordinary people. They and their Moon-based knowledge were rooted out in vicious inquisitions and they were rounded up and tortured, burned or drowned. Moon worship went underground, as did much old wisdom about the powers of human thought and emotion, climate predicting, and planting knowledge.

Much of this remains suppressed today, although two traditions persist. One is concerned with the time of birth. A child born upon a full Moon, it is said, will be strong; and long life will come to those born when the Moon is one day old; however, the dark of the Moon is the most unlucky time for birth. The other tradition is success in harvesting.

> Diana… Diana… Diana
> I am summoning
> Forty-five spirits from the west!
> I am summoning forty-five spirits from the east!
> Rains, rains, rains,
> Give from your wide skies, burst water upon us!

Behold our wine in your chalice,
Accept our offerings to you!
Send the dark clouds over us,
Surround our fields with stormy rains,
You who wield the thunderbolts,
We call upon thee!
Blessed be! Blessings be!

– From *The Dianic Tradition and the Rites of Life*
by Zsuzsanna Budapest

planting by the moon

Generations of farmers have always planted by the Moon. Because rainfall, temperature and light affect the germination of seeds it was important to know how the Moon affected weather. When the Moon passed in front of a particular constellation, cultivation, sowing and planting were enhanced.

For instance, when the Moon passed in front of the sky region of Leo, not only was the formation of fruit and seed furthered, but the quality of the seeds was enhanced. The four formative trends appear in sequence – root, flower, leaf, fruit/seed – and these trends are repeated three times in the course of 27 days. The duration in which each impulse is active varies in length between one and a half and four days. The inner quality, though, was considered to be individual to each constellation, which puts the Moon as the reflector of the ever-changing quality of the Sun throughout the course of the year.

Almost all cultures we know of throughout ancient history have devised farming 'clocks' around the month, so that crops were planted and harvested at particular phases.

Moon region	Astrological name	Affect on
Bull, Virgin, Goat	Taurus, Virgo, Capricorn	Root development
Twins, Scales, Water Carrier	Gemini, Libra, Aquarius	Formation of the flower
Crab, Scorpion, Fishes	Cancer, Scorpio, Pisces	Leaf region
Lion, Archer, Ram	Leo, Sagittarius, Aries	Fruit/seed region

observations of the **maori**

For the Maori in pre-European New Zealand, the month was a purely lunar one, commencing with the new Moon – or rather, with the *Whiro* night, when it is not visible. The named nights of the Moon's age therefore always presented in the same aspect and served as a reliable calendar. Maori farmers began planting kumara (sweet potato) on the nights called *Oue, Ari, Rakaunui, Rakaumatohi, Takirau* and *Orongonui*, which were the 4th, 11th, 17th, 18th, 19th and 28th nights of the lunar month. No planting was done during full Moon nor on *Korekore* days (21st, 22nd, and 23rd nights), for it was believed that very poor crops would result. Although absolute uniformity was rare among the various tribes of the Maori people, due to scattering and diversity, most planted close to these dates. The planting months were in spring: September, October and November.

> Kumara was planted at the time when the Moon is due north at sunset or twilight, and the planting may be continued for three days. Some tribes planted the tubers only during spring tides, that is for a period of three days at that period.

An exception seems to have been for gourds, which were grown not for food but for storage of seeds or water. Because they required rapid vigorous growth, gourds were generally planted *on* the full Moon. This practice seems widespread. A publication of the Bishop Museum in Honolulu states that the giant Hawaiian gourd, *Cucurbita maxima*, was cultivated in pre-European Hawaii in this exact lunar period. It seems to have been common practice throughout the Pacific.

Fishing was similarly tied to lunar events. Certain winds were known to blow at certain times of the month. To the eastern Maori, four days after new Moon came the 'Winds of Tamatea', which turned to blow from the east, bringing wind and a rougher sea – at least, on the East Coast. Fishermen did not venture out to sea during this period.

Some Moon phases were said to bring more fish. Although there was no written language, the Maori had a rich artistic culture and fishermen kept tallies using an intricate system of symbols.

Beside is a list of the Tuhoe tribe's names of the 'nights of the Moon' as the Maori put it (for they spoke of 'nights' where we use the term 'days'), together with their value as fishing nights for the fish called Kokupu.

The typical Maori fisherman's calendar looked like a series of dots, dashes, crosses and L shapes. Perhaps it was all that remained of what might once have been an almanac compiled in other lands, from information accrued over thousands of years. There is physical evidence that the Maori may have replaced (by extermination) the much earlier inhabitants in New Zealand, who it seems dominated the Pacific at one time with their standing-stone culture. Until very recent times in New Zealand these shadowy forebears were referred to as the real tangata whenua (ancestral claimants to the land). In oral tradition they were *Uru-kehu, Turehu, Patupaiarehe*, 'the fairy folk', 'Children of the Mist', 'Enlightened Ones' and according to legend, were a race fair skinned and red haired. There is growing speculation now that these ancient inhabitants would have used the latitudes of the South Pacific for Venus transit mapping as they reportedly did in their

tuhoe lunar fishing calendar

1	Whiro	Good fishing.
2	Tirea	
3	Hoata	
4	Oue	
5	Okoro	Poor nights for fishing. Kokopu do not sleep soundly.
6	Tamatea-tutahi	
7	Tamatea-anana	
8	Tamatea-aio	Very poor fishing nights. On the *Ari* night the light of the torches will alarm the fish and so they dart away. On the *Huna* night the fish are concealed.
9	Tamatea-kaiariki	
10	Ari-matanui	
11	Huna	
12	Mawharu	
13	Maure	
14	Ohua	Fishing impossible. Moonlight too strong, fish cannot be approached.
15	Atua	
16	Hotu	
17	Turu	
18	Rakau-nui	
19	Rakau-matohi	
20	Takirau	
21	Oika	
22	Korekore	
23	Korekore-piri-ki-te-Tangaroa	
24	Tangaroa-amua	Fishing may be successful after midnight.
25	Tangaroto-aroto	
26	Tangaroa-kiokio	
27	Otane	
28	Orongonui	
29	Mauri	
30	Mutuwhenua	

countries of origin much farther to the north.

There are many standing stone structures still in New Zealand that mathematically match ratios found at Stonehenge and the Great Pyramids at Giza. It may be that an ancient internationally far-flung civilisation, probably pre-Celtic but definitely Middle Eastern/European, at one time extensively occupied most Pacific islands from New Zealand to Easter Island. Virtually commuting to and from Europe in their large ocean-going craft, they would have made extensive use of the Bering Strait and North-west Passage, through which it is almost a straight line from the British Isles to New Zealand's North Island.

If that were so, the Maori may have inherited their lunar fishing and planting calendar from those earlier peoples. Many of the names of Maori gods, like Rangi, Rongo and Maui, are also those of Egyptian and Babylonian deities. The beginning of the Maori New Year was the European/Middle Eastern June new Moon coinciding with the appearance of the Pleiades, located in Taurus. Today this cluster is popularly known as the Seven Sisters but in ancient Greek mythology it was the Seven Daughters of Atlas. The Maori called it Te Matariki.

Oral traditions among peoples of the South Pacific have transmitted data by word of mouth down through the generations. The almanacs would have become story-oriented, working oral texts under the command of tohungas, (priest-astronomers) who were in charge of the Moon perigee sticks which played such a large role in Maori agriculture and fishing.

But in the north, books started appearing. The Greek poet Hesiod's monthly calendar of *Works and Days* was written seven centuries before Christ was born. This was a written calendar timed to the Moon phases for the whole year, and describing weather, planting and social information. It included advice on when to geld horses, when to hunt birds and when the north wind would blow.

> At the time when the Pleiades, the daughters of Atlas, are rising
> begin your harvest, and plough again when they are setting.
> The Pleiades are hidden for forty nights and forty days,
> and then, as the turn of the year reaches that point
> they show again, at the time you first sharpen your iron.
>
> But if the desire for stormy seagoing seizes upon you
> why, when the Pleiades, running to escape from Orion's
> grim bulk, duck themselves under the misty face of the water,
> at that time the blasts of the winds are blowing
> from every direction
> then is no time to keep your ships on the wine-blue water.

Other passages in Hesiod's *Works* suggest that the disappearance of these particular stars around the full Moons and perigees (when the Moon is closest to the Earth) of October and November was associated with the deterioration of the weather, with consequent danger particularly to sailors. The second halves of those months were the worst.

> October: Do not sail
> November: Haul ship on land.

There is even a right time and a wrong time in Hesiod to have sex:

> then is when the goats are at their fattest, when the wine tastes best,
> women are most lascivious, but the men's strength fails them most,
> it shrivels them, knees and heads alike.

This corresponded to early July in our calendar, when women are most desirous but men are in their most dried-up condition!

For the opposite case, consider the daytime of about 12 September:

> the feel of a man's body changes
> and he goes much lighter.

Closer to our period, in 1688, an author wrote:

> the double conjunction of Venus and the Moon produces extreme
> lubricity, brings venereal disease, and causes women of quality to
> become enamoured of menservants.

moon **madness** and ill winds

On 24 June 1994 a tremendous thunderstorm over London filled the hospitals' accident and emergency departments. Ten times as many people as would normally be seen for breathing problems were registered in the 30 hours after the storm, and almost half those affected had never suffered asthma before. Many hospitals ran out of inhalers and drugs, and staff were stretched to the limit.

On top of this there were more than 50 ground strikes of lightning just prior to the deluge. Interestingly, 24 June was the day of the June full Moon. It was also two days after the perigee.

A lot of data has been collected connecting weather and human activities – from the increase of domestic disputes and violence around the full and perigee Moon, to the frequency of the borrowing of non-fiction books, in public libraries. No one has explained why these astronomical facts should be relevant.

Although the full Moon alone has been said to account for increased incidents of epilepsy, heart attacks and crime, mostly these reports are dismissed as folklore because medical science would wish that modern thinking has gone beyond the primitive belief that the Moon can make you sick.

Consider the word lunacy. As recently as 1842 in Britain, the Lunacy Act declared that a lunatic was someone who was 'rational during the first two phases of the Moon and afflicted with a period of fatuity in the period following the full Moon'. Madness caused by the Moon has been cited as defence in murder trials, as well as an explanation for drunkenness and theft. Crowd behaviour is said to magnify, for the good or the bad.

Whether or not you wish to believe the claims, it is true that the

superintendents of mental hospitals used to put extra staff on when a full Moon was expected and even gave inmates a precautionary whipping. Yet there is evidence of more admissions at full Moon. Patients already admitted may be more disturbed then than at other times. The Philadelphia Police Department reported that cases of fire-raising, kleptomania, homicidal alcoholism and other crimes against the person increased in number as the Moon waxed and then decreased as it waned.

Dr Frank A. Brown of Northwestern University took oysters from Long Island Sound on the east coast of the USA and moved them a thousand miles inland to Evanston, Illinois. In darkened, pressurised tanks, the oysters continued to open and close their valves to the rhythm of the tides at Long Island. After two weeks they gradually changed their rhythm to that of the tides at Evanston *if* that city had been on a coast. Although shielded from the light of the Moon, the oysters were clearly governed by its movement relative to the Earth at that location, indicating that their body clocks were affected by changes in terrestrial magnetism for which the Moon was responsible. If oysters were affected in this way, it is conceivable that humans would be too. Many have always thought so.

There is an old Cornish saying, 'No Moon, no man.' A baby born when no moon was visible would not live to be adult. In north-west Germany the Moon was regarded as a midwife, because births were believed to be more frequent when the tide was rising, just as many coastal inhabitants believed deaths occurred on the outgoing water. Are these merely old wives tales?

Studies verify some of this. In a study of more than 11,000 births over a period of six years at the Methodist Hospital of Southern California in Los Angeles, it was found that six babies were born when the Moon was waxing (before full Moon) to every five born when it was waning (after full Moon). Similar results were obtained in Freiburg, Bavaria, by Dr W. Buehler after studying 33,000 births, with the added refinement that boys tended to be born on the wax and girls on the wane.

Does the Moon affect other bodily processes? Dr Edson Andrews, a Florida ear-nose-and-throat surgeon, found 82 per cent of his patients bled and needed urgent operations around the time of the full Moon. Dr F. Peterson found that in his Chicago practice, tuberculosis sufferers were more likely to die just after the full Moon and least likely on the eleventh previous day, probably because of Moon-induced changes in the acidity or alkalinity of the blood. This is of interest in my family because the mother of my children, terminally ill with cancer, died on 14 July 1995, two days after the full Moon in perigee.

Perhaps the effects are due to a gravitational pull of bodily fluids, or perhaps there is, as Dr Leonard J. Ravitz suggests, a link between lunar phase and changes in the electrical field that surrounds the human body.

Returning to the menstrual enigma, in the 1920s a Swedish chemist, Svante Arrhenius, kept records of 11,807 menstrual periods, compared them with the phases of the Moon and found they were more likely to start when the Moon was waxing than at other times. This places ovulation 14 days earlier, around or just after new Moon, which supports a scenario of primitive *Homo sapiens* mating during the dark Moon time.

But unfortunately for the case, there must be many thousands of women who could produce contradictory results.

Nevertheless, the premenstrual syndrome is by now well established. Of the women surveyed in Britain's Holloway Prison 63 per cent committed crimes during their premenstrual or menstrual period. In girls' schools a similar pattern emerges for menstruating pupils: absenteeism, clumsiness, rebellion and low exam performance.

Even wind *directions* seem to affect us. The sirocco is an oppressive hot dry southerly wind blowing from the Sahara towards the north coast of Africa. By the time it crosses the Mediterranean to Europe it has become cooler and eventually moist. It is renowned for causing sluggishness and mental debility.

In south-east Australia the Southerly Buster is a sudden cold southerly wind. It follows a warm northerly and can make the temperature drop

20°C (36°F) in a matter of hours; it induces miserableness and depression.

In the normally tropical Central American highlands, when the cold norther hits, many Indians contract fatal pneumonia – just as many in North America get head colds in early spring. And in Canterbury, New Zealand, the cold breezes from the south can cease as the warm north wind from the tropics takes over. Visitors are warned: a nor'wester will make you lethargic.

A nameless east wind that blows over London only in the months of November and March was once linked by an eighteenth-century British court physician to regicide. Voltaire quotes the doctor, an acquaintance, as saying the wind caused:

> black melancholy to spread over the nation. Dozens of dispirited Londoners hanged themselves, animals became unruly, people grew dim and desperate. Because of that east wind, said the doctor, Charles I was beheaded and James II deposed.

Schoolteachers will complain that schoolchildren 'play up' more in dry weather than in humid conditions. When a wind is blowing they become more unsettled and cannot queue properly in line; and students seem to do better in exams when the Moon is in perigee, full or new, and/or if gusty weather is occurring outside the exam room. Just why this is so seems to be linked to the Moon's often-recorded influence in battles.

Plutarch observed that a big battle is often followed by rain, and the notion that warfare somehow causes rain has surfaced during every war. It was still flourishing in the muddy trenches of World War I. The idea is that the sweat of soldiers produces rising rain-stimulating vapours... or that the waters are shaken from the clouds by the noise of cannon. But perhaps it is simply that men fight more when their adrenalin systems are stimulated by the lunar cycle, and the same gravitational effect that the Moon exerts to produce a storm or weather change will also produce a type of micro-storm within a person's head. (There would be a use, too, for a sympathetic climatic backdrop to the drama and excitement of an imminent battle.)

There are several examples of this. In January 1777, during the early

days of the American Revolution, George Washington found himself trapped fighting against the British garrisoned at Princeton. On 2 January the wind changed to the north-west and the roads began to freeze. Washington immediately took the offensive. He slipped out of the trap, marched his inspired army 12 miles to the outskirts of Princeton in the dead of night, and caught the British by surprise. It was a new Moon.

The weather on 6 June 1944 was marginal, with choppy seas and overcast skies. It was the Allied invasion of Normandy. The Germans, doubting an invasion in such inclement conditions, were caught completely off guard. It was the week of the Moon's perigee and the day of the full Moon. Perhaps another coincidence?

No one can deny that aspects of the environment are predictable. Day follows night, summer follows winter, most of us sleep when it's dark, eat at midday and watch the weather report about 7pm. Random events are for the most part whimsically quaint, as when the phone rings and it turns out to be the person you were thinking about. Oh, you exclaim, I must be psychic. But there is also a likelihood that, unknown to you both, some parallel pattern exists between your life and your friend's life.

The trade winds blow steadily between latitudes 10° and 30° – from the north-east in the northern hemisphere and from the south-east in the southern hemisphere. Of importance to merchant sailing ships dependent on wind power (hence called 'winds that blow trade' by eighteenth-century navigators), the trade winds shift direction in a predictable way according to the seasonal shift in the high-pressure belts.

They made the traffic in black slaves possible from the sixteenth to the late nineteenth century. Taking advantage of the prevailing winds, ships voyaged from Europe to Africa's Guinea Coast with goods to be exchanged for human cargo. Loaded with slaves the ships sailed across the Atlantic to the West Indies and thence Charleston, South Carolina, there to barter the slaves for sugar, rum or cotton. Then they would follow the American coast northwards and return to Europe on the more northern prevailing westerlies to complete the trip.

Early sailors also relied on the Roaring Forties. These are winds

occurring at 40° S latitude which blow steadily around the Horn. They were formerly known as the Brave West Winds.

The monsoon is time-predictable (blowing towards Asia at the end of May and in the opposite direction at the end of October) and has always played an important part in the economy of the Middle and Far East. It blew the frail craft of the first adventurous traders from the east coast of Africa across the Indian Ocean to the rich Malabar Coast of India. By the first century AD, Arabian mariners, trimming their sails to it, fared safely north-east across the Gulf of Aden to the mouth of the Indus River. Three centuries later, they rode the steady monsoon winds all the way to China.

Even today, India's economy is at the mercy of the monsoon. The country's huge rice crop, the staple food for millions, depends on moisture that the monsoon brings from the Indian Ocean. The Greek word *mene* means Moon, while the words monsoon and season derive from *mausim,* the Arab word for Moon.

Nature is predictable. The whole thrust of science is towards discovering nature's patterns. Obviously, to begin with there must be an assumption that some predictable patterns exist. As discoveries are made, more patterns are revealed. It would be more unusual to find that events occur in isolation with no precedence or subsequence. In fact, there's a case for there being no true randomness, because what we know of randomness is also something predictable.

So it is with the weather, which is caused by the behaviour of the Moon. There is nothing mysterious about the Moon's motion; it has been measured extensively and is predictable.

But we cannot easily see slow movements. Try watching a child grow or the big hand of a clock move. Because we do not observe slow changes unless we write them down, we easily miss the variations in the way the Moon moves and appears – changes visible to the naked eye that can occur within just two days. Little wonder, then, that memories of some changes of movement over longer periods – like certain cycles encompassing 19 years, 133 years, 679 years, and more

– go unnoticed by most people. Indeed most of us can't remember what the weather was doing last week. Let us look at these changes, starting with the most obvious.

through the phases

Ohe of the most familiar things about the Moon is that it goes through phases from new (all shadow) to first quarter (half of it appears to be in shadow) to full (all lit up) to last quarter (or third quarter, opposite to the first quarter) and back to new. This cycle takes about 29.53 days and is known as the Moon's *synodic* period.

The Moon moves through four visibly differentiated phases in about four weeks. New Moon to first quarter, to full Moon, to last quarter, and back to new Moon again, occurs at nearly seven-day intervals.

We know that the phases are so called because of the way the Sun illuminates the Moon – because of the relative positioning of the Sun, Earth and Moon. We observe that not much of the Moon is illuminated when it is close to the Sun. The smaller the angle between the Moon and the Sun, the less we see illuminated. When the angle is within about 6° we see it in a new phase. Sometimes that angle is 0° and we have a solar eclipse – the Moon is in new phase and it is covering up the Sun. Conversely, the greater this angular distance between the Moon and the Sun is, the more we see illuminated. At about 180° we see the Moon in full phase. Sometimes (about twice a year) the Moon–Sun angle is exactly 180° and we see the Earth's shadow covering the Moon – a lunar eclipse.

The table below gives a summary of when the Moon is visible and where to look. This applies everywhere in the world at approximately the same times.

PHASE	RISES in eastern sky	CROSSES southern sky in northern hemisphere, northern sky in southern hemisphere	SETS in western sky
New Moon	Sunrise	Noon	Sunset
First Quarter	Noon	Sunset	Midnight
Full Moon	Sunset	Midnight	Sunrise
Last Quarter	Midnight	Sunrise	Noon

During its phases the Moon does not shine with its own light but gets its light from the Sun, as the Earth does. The shape of the Moon seems to change a little from night to night. But the Moon doesn't really change shape. Because the Moon circles the Earth once every day, only those on Earth who are in relative darkness can see it, and what they see is only the part of the Moon that has sunlight falling on it. Most of us no longer believe that the Moon is born again when new and then dies on the wane, or that, as was the belief in Morocco, a completely new Moon comes each month, and the place where the dead dwell, paradise, is full of old Moons.

We look at the Moon almost every time we look up and think we know it. But many people do not realise finer points that Moon watchers take for granted – for instance, that a full Moon can be seen only at night (between sunset and sunrise) and never during the day. Or that during each month, for any location there is one day near last quarter when the Moon doesn't rise, and one day near first quarter when the Moon doesn't set.

The phases bring their own weather patterns. Cloudiness is influenced by small-scale local topography – ridges, bodies of water, hills and cities. But atmospheric-tidal effects make cloud formation predictable to some degree – the presence of clouds depending on whether or not the Moon is risen or has set. For instance, around a new Moon, if rain is about (as in the colder months), then we can more expect it between early evening and the following dawn, the skies being generally clearer during the day.

At the beginning of its phase cycle, if you could imagine three balls viewed from above, being the Earth, Moon and Sun, it would be as if the Moon in the middle starts to move anticlockwise away from the Sun and around the Earth. Of course the Earth is spinning all the while within the Moon's orbit. Every time the Earth moves 360°, the Moon moves 12°.

The following Moon shapes apply to the northern hemisphere. In the southern hemisphere the Moon image is reversed, so just think of it the other way round.

new moon

The new Moon cannot be seen during the day as the Sun's glare is too strong, nor at night, when it is on the other side of the world. In fact, trying to see an extremely 'young' Moon is a sport in itself. The record is 14.5 hours (two English housemaids in 1916). But at any age under 24 hours the Moon is breathtakingly thin and barely brighter than the low, dense sky around it.

After a day the Moon appears as a thin sharp-horned crescent shape suspended above the western horizon, its cusps always pointing away from the Sun, which has already set. At this stage it sets shortly after sunset.

When it is two or three days out from new Moon, it goes by the name of waxing crescent.

waxing crescent

Any cloud around breakfast time may clear by 10am and stay clear until early evening.

In days following, it grows (waxes), appearing when viewed from Earth at sunset farther away towards the east. It rises about an hour later each day and about a week after new Moon; appears as the familiar 'half-Moon' shape, the first quarter, which is overhead at sunset.

first quarter

The first quarter is the Moon you see in daylight in the afternoon. Its glare (nearly four times fainter than that of the full Moon, surprisingly) is in the sky in the evening, but if you wait until about midnight it will go down.

Typical weather of the first quarter is cloud or rain (if about) before lunch, with clearer skies from lunchtime to midnight. In our overhead view the Moon is now to the right of Earth, and forming a Moon–Earth–Sun right angle. Because the Moon is sitting on our orbital path around the Sun, three and a half hours ago the Earth was where the Moon now is.

In the northern hemisphere the first quarter appears, when viewed from ground level on Earth, as a D shape. This is reversed 'down under' in the southern hemisphere because viewers there would need to be standing on their heads to see the D. (Writing from the southern hemisphere, the little reminder I use is that when the Moon is approaching full it is 'Coming' and I think of the C shape. When it is on the other side of full and approaching new it is 'Departing' and I think of the D shape. As it is the reverse in the northern hemisphere, I suggest that readers there adopt 'expanDing' and 'Collapsing'.)

A few days later in the month, more than half its visible disc is lighted, which is referred to as waxing gibbous (gibbous comes from the Latin word *gibbosus* meaning humpbacked).

waxing gibbous

It can be seen high in the east late in the afternoon, and skies are more likely to remain clear until the wee small hours of the next morning. Any cloud or inclement weather generally appears in the early morning and could last until just after lunch.

full moon

When it reaches full Moon phase the Moon is most prominent, rising opposite the setting Sun and illuminating the sky all night with a pale yellow light. It is in the sky all night, so bright that you can't see any stars except the major constellations.

There are more superstitions about this phase than any other. It is bad luck to view the full Moon through the branches of a tree, and the full Moon has been said to cause madness, cause hair to grow on werewolves, increase crime, eat clouds, swallow the wind and cause rain on a Saturday. The last would appear to hold some truth; investigations from a variety of sources have shown that violent storms are prevalent around the full and new Moons.

From above and looking down, it would appear as if the Moon was on the opposite side of the Earth to the Sun. When we gaze up at the full Moon and see the night sky beyond it, we are gazing into the far reaches of the universe, beyond the limit of our orbit around the Sun, into space we never as a planet enter.

Full Moon is called a night Moon because this is the only time it is in our sky. After the full Moon is a couple of days old, some people may claim to be able to see it in the early morning, but it is no longer really a full Moon.

During the full Moon phase, cloud and rain (if about) will appear mainly during the day, but it clears by evening and stays clear until sunrise the next day.

Two weeks have now passed since new Moon. Continuing on its relentless orbit, the Moon comes around the Earth on the far side to

once again approach the Sun. A few days out from full Moon, it has become waning gibbous.

waning gibbous

The Moon's appearance is now an exact mirror image of the waxing crescent. From just before lunch until just before dinner is the likely period for cloud, whereas the skies are more likely to be clearer from an hour or two before midnight until mid-morning the next day.

last quarter

A week after being full Moon, the Moon is overhead at sunrise and is called third or last quarter. It now looks like a C in the northern hemisphere and a D in the southern hemisphere. A mirror image of the first quarter, it is said now to be 'on the wane'.

Having risen progressively later during the night, it remains in the sky well after the Sun has come up. It is the Moon seen by daylight before lunch. Now its position marks where Earth will be in space (on our orbit around the Sun) in three and a half hours time.

At last quarter one can typically expect any cloud or rain that is about to be overhead in the afternoon and early evening, clearing somewhat by about 2am the following morning, with skies staying reasonably clear until lunchtime the next day.

Two or three days later the cloudiness appears mainly in the evening through to midnight. Some time in the night the skies are more likely to clear and stay clear until late afternoon the next day. Now the Moon is known as waning crescent.

waning crescent

In this phase the Moon appears as a mirror image of the waxing crescent. Reduced to a thin banana shape, the gradually vanishing sliver can be glimpsed rising low in the east before sunrise, before

vanishing altogether for a couple of days as it becomes lost in the glow of the Sun's light.

We are at the month's end, the disc is gone. When we see no Moon we speak of the 'new Moon', but this is a misnomer because it is not really renewed until we see its crescent again a few days later in the evening twilight.

The whole phase process takes 29.5 days. In early civilisations, weeks originated as quarters of this lunar cycle. If new Moon fell on a Sunday, so would first quarter, three times out of four.

Later we will consider more fully how each of the four phases can affect the weather. But for now, we need to have a closer look at gravitation.

through the phases

tides and what pulls what

T he weather is nothing more than the Moon pulling the atmosphere around. Why it should do so is simple Newtonian physics, and how the weather around the world varies is a consequence of variations in the movements of the Moon. First, we will examine the phenomenon of gravitational pull, and then what exactly is being pulled. Finally in this chapter we will discuss how this varies in the short and long term.

what's a **tide**?

It looks as though the Moon revolves around the Earth, but actually the Moon and Earth revolve together around their common centre of mass, or gravity. The two astronomical bodies are held together by gravitational attraction but are simultaneously kept apart by an equal and opposite *centrifugal* force produced by their individual revolutions around the centre-of-mass of the Earth–Moon system. At local points on, above, or within the Earth, these two forces are not in equilibrium, and oceanic, atmospheric, and earth tides are the result.

The centre-of-revolution of this motion of the Earth and Moon around their common centre-of-mass (barycentre) lies at a point

approximately 1720 km (1068 miles) beneath the Earth's surface, on the side towards the Moon, and along a line connecting the individual centres-of-mass of the Earth and Moon.

oceanic tides

The oceanic tides are caused by different strengths of the Moon's gravity at different points on the Earth. The side of the Earth facing the Moon is about 6440 km (4000 miles) closer to the Moon than the centre of the Earth is, and the Moon's gravity pulls on the near side of the Earth more strongly than on the Earth's centre. This produces a tidal bulge on the side of the Earth facing the Moon. The Earth rock is not perfectly rigid; the side facing the Moon responds by rising towards the Moon by a few inches on the near side.

The more fluid sea water responds by flowing into a bulge on the side of the Earth facing the Moon. That bulge is the high tide. At the same time the Moon exerts an attractive force on the Earth's centre that is stronger than that exerted on the side away from the Moon. The Moon pulls the Earth away from the oceans on the far side, which flow into a bulge on that far side, producing a second high tide on that side.

These tidal bulges are always along the Earth–Moon line, and the Earth rotates beneath the tidal bulge. When the part of the Earth where you are located sweeps under the bulges, you will notice a high tide; when it passes under one of the depressions, you experience a low tide.

The Sun's gravity also produces tides that are about half as strong as the Moon's and produces its own pair of tidal bulges. They combine with the lunar tides. At new and full Moon, the Sun and Moon produce tidal bulges that add together to produce extreme tides.

tides slow earth's **rotation**

As the Earth rotates beneath the tidal bulges, it attempts to drag the bulges along with it. A large amount of friction is produced which slows down the Earth's spin. The result is that the day has been getting longer and longer by about 0.0016 seconds each century.

Over the course of time this has a noticeable effect. Astronomers trying to compare ancient solar eclipse records with their predictions found that they were off by a significant amount. But when they took the slowing down of the Earth's rotation into account, their predictions agreed with the solar eclipse records. Also, growth rings in ancient corals about 400 million years old show that the day was only 22 hours long then, so that there were almost 400 days in a year.

Gravity acts both ways. Eventually the Earth's rotation will slow down to where it keeps only one face towards the Moon. The Earth has also been creating tidal bulges on the Moon and has slowed its rotation so much that now it rotates only once every orbital period. For that reason the Moon now keeps one face always towards the Earth.

Oceanic tides occur with a dominant period (the time between successive high or low tides) of 12 hours and 25 minutes. High tide comes twice a day: once under the Moon (or somewhat behind it, because friction with the solid Earth delays the water), and once when the Moon is on the opposite side of the Earth.

The Sun also has a tidal pull on the Earth, rather less than half that of the Moon. So at or just after the new and full Moons of each month, when Sun, Moon and Earth are in line, the tide is amplified into a 'spring' tide (nothing to do with the season called spring).

There is a tidal swelling on *both* sides of the Earth. So whether spring tide is at new or full Moon, if there is one flood tide under the noonday sun, the other is at midnight.

As high tides are produced by the heaping action resulting from the horizontal flow of water towards two areas of the Earth (representing positions of maximum attraction of combined Moon and Sun), low tides are created by a compensating maximum *withdrawal* of water

from areas around the Earth midway between these two humps. The alternation of high and low tides is caused by the daily (diurnal) rotation of the Earth with respect to these two tidal humps and two tidal depressions.

Normally there are two tides a day, called semi-diurnal. When there is only one tide per day, this is called diurnal tendency and is caused by lunar declination, 28.5° from the equatorial plane.

Twice a sidereal month (just under 15 days) during full and new Moon the tides are the strongest tides, the spring tides. At first and last quarter of the Moon's phases the Sun and Moon pull at right angles to one another, and the tides are weakest, the neap tides.

When the Moon is near (that is, in perigee) its tidal pull is greater. Perigees will be discussed a little more fully in the next chapter. Perigees are greater when they coincide with new or full Moon. At these times of coincidence, we expect the highest tides of the year and the lowest low tides – the tides of greatest amplitude. Perigean spring tides may cause coastal flooding, especially if, as is usually the case, they happen to be accompanied by storms. This is because the Moon in perigee acts in a more pronounced way on the *atmospheric* tide as well. There will be more about this in succeeding pages.

The tidal day is 24 hours 50 minutes, longer than 24 hours because of the lunar orbit. The Earth–Moon tidal coupling lengthens the day; this lengthening is due to tidal friction.

Can the tide influence the wind? All motion and all energy are relative. Consider two large masses such as some of the Earth's atmosphere (air) and some of the Earth's surface (ocean). There is friction produced between the two bodies when they are not both at rest. When one of them starts moving – air across calm water, or tidal motion underneath still air – the other will also be made to move because of friction at the surface point of contact. It is not just here and there; considering the huge areas of ocean involved, there is a phenomenal friction effect. That is why a fog will often roll in on the tide.

Blow across a saucer of water and watch what happens. The amount

of energy transferred will depend on the size of the masses, the area of the surfaces in contact, the roughness of those surfaces, the relative motion and the duration of the surface friction.

Just as the wind whips up the waves, so do the waves affect the wind. The air will be swept along by waves together with the swell if significantly large, because travelling waves encapsulate and pass on pockets of air. Between the Tropic of Cancer and Tropic of Capricorn, the trade winds and main sea currents flow in the same direction.

What if there were no Moon? Without a Moon in the sky there might be no life on Earth. The Sun would evaporate the water of the seas to a cloud, and the Earth would revolve inside the cloud. This enormous cloud would face the Sun all the time because the Sun would be the only gravitational attraction on Earth.

The Moon is slowing the Earth down. The second consequence of the Moon's pull on Earth is to slow Earth's rotation. As Earth's rotation speed decreases, the Moon must move farther from Earth to conserve angular momentum. This process is slow. Every 350 years we have to add another second to the length of our year.

Tides also occur in large lakes, within the solid crust of the Earth, and in the atmosphere. The latter really *are* 'high' tides!

atmospheric tides

The Sun is the major source of energy available to the Earth. At the Earth–Sun distance of 149,600,000 km (93,000,000 miles) about one two-billionth of the Sun's outpouring of energy (mostly in the visible-light range of the spectrum) is intercepted by us. Most of this is absorbed by the atmosphere and the solid Earth, consequently heating the gas of the atmosphere and the rock and water of the surface.

The atmosphere is a layer of gases 320 km (200 miles) thick, which, along with the body of water we call the sea, is held to the Earth by our own gravity. Without this gravity all the oceans would fly off into space. The atmosphere would go too.

What does the atmosphere weigh? The total weight of Earth's

atmosphere is about 4.5 x 1018 kg, or nearly five thousand million million tons. Thus the weight of the atmosphere per unit area, or its pressure, is about a ton per square foot at sea level. A layer of water about 10 m (33 ft) deep sitting on the Earth at every point would exert the same pressure at the Earth's surface as does the atmosphere.

The scale of the atmosphere is incredible. The imagination can only boggle at something weighing so much that can (and frequently does, when the Moon dictates) move so fast. There is no sea tide remotely like it.

On a hot afternoon the atmosphere picks up water from the Gulf of Mexico at the rate of 5.5 billion tons an hour, hoists it up and carries it north-east by the millions of tons, to release it later as rain over New York and southern New England. A single, small, fluffy cloud may hold up to 1000 tons of moisture. A summer thunderstorm may unleash as much energy in its short life as a dozen Hiroshima-style bombs, and 45,000 thunderstorms are brewed around the Earth every day. Yet one hurricane releases almost as much energy in one second.

The very size of the atmosphere offers protection, or shielding, between the Earth's surface and space. Without the shielding of the atmosphere, life could not continue on Earth; and without the atmosphere, life could not have developed on Earth, at least in the form in which we know it. The Sun emits high-energy radiations – ultraviolet and X-rays – and even more energetic radiations – cosmic rays – pervade space, and these radiations would kill living things. We know that they enter the atmosphere in lethal amounts but are stopped long before reaching the surface. The absorption by the atmosphere of these powerful forms of radiation accounts for many of the properties, particularly electrical, of the higher atmosphere.

The atmosphere shelters us from the fierce heat and cold of space, filters out damaging rays of sunlight, and burns up several million billion meteors each day to harmless cinders before they reach the Earth's surface. It pulls up water from the ocean surface and recycles it to nourish life all across the planet.

What constitutes the atmosphere? The mixture of gases is generally

called air. Its main constituents are nitrogen and oxygen, in a ratio of about four to one. Weather, as it affects humans, is mostly confined to the lowest 15–25 km (9–15 miles) of the atmosphere, for it is in this lowest part that most of the mass of air is contained.

There is also weather in the *upper* part of the atmosphere from about 60 km (37 miles) above the Earth to a height of 300 to 1000 km. Strong winds, storms, and great electrical manifestations such as auroral displays occur there. This is because the upper atmosphere is also a chemical laboratory. In its near-vacuum conditions, in the presence of high-energy solar radiations, some of the atmospheric gases react chemically with one another.

The atmosphere extends from the Earth's surface outward, becoming less dense. The Sun, too, has what we call an atmosphere, streaming out into space far beyond the orbit of the Earth, well into the outer reaches of the solar system. This so-called *solar wind* flows around the Earth's magnetic field, creating an elongated cavity within which the Earth's atmosphere is confined.

Life's dependence on the atmosphere is not a one-sided relation, for an atmosphere of some sort surrounding primeval Earth not only allowed life to originate and develop but also was itself modified, perhaps considerably, by living things. The free oxygen in the atmosphere, for example, would not exist without plant photosynthesis.

Humans really live at the bottom of a sea of air, at or near the top of a sea of water, and these two 'seas' are interrelated. Their reaction with each other is one of the important factors in weather. Weather is simply the state of the atmosphere: is the air cool or hot? dry or moist? still or in motion (windy)? clear or cloudy?

But from space, the atmosphere looks very thin. If the Earth were a round party balloon, the atmosphere would be only as thick as the rubber enclosing the air. If the Earth were the size of a 'medicine' ball, the atmosphere would be only 1 mm more in diameter. On that scale the amount of water in the seas would be only a tablespoonful, tipped onto the 'medicine' ball. This seems surprising, but if the seas covered the earth uniformly, they would average only 1 km (²/₃ mile) deep.

Just as the seas are free to move, so is the atmosphere, which is exactly like another sea, only less dense and able to move faster. Water is 300 times heavier than air. We have no trouble accepting that the Moon moves the seas. Obviously then, moving the air is easier! But it nevertheless behaves as a liquid. And move it does, constantly.

The atmosphere is invisible to us. We don't see it, any more than a fish sees water. Everything we sense is due to its presence, for smells are carried on the wind, sounds are really air compressions, feelings on our skin surface are partly due to temperature changes, and visible colours are affected by the air that diffuses light.

The Sun heats the atmosphere. The atmosphere is heated by the Sun when the Sun heats the tropics, which is that part of our planet around the equator between the Tropic of Cancer (the northern tropic) and the Tropic of Capricorn (the southern tropic). The word tropic means 'to turn'. The northern and southern tropics were the apparent limits of the northern and southern passages of the Sun. To peoples long ago they were the equinoctial points at which the Sun 'turned back' towards the Earth, as viewed from the ground. We still call this band the tropics – virtually the area of the Earth containing all places between imaginary latitude lines running through Mexico–Sahara–Calcutta and Rio de Janeiro–Johannesburg–Brisbane.

Air has mass. A submarine with fins and propellers is held buoyant under water because water has mass and can support something moving through it; an aeroplane with fins and propellers is held up for the same reason. Air has weight. This can be proven by balancing an inflated balloon and a deflated one on either end of old-fashioned scales and seeing if one end goes down.

Because the atmosphere has mass it can be (and is) pulled around by the Moon. Just as we have sea tides, we also have atmospheric tides.

The atmosphere shields us from the Sun's fierce rays and from the extreme cold of outer space. It acts as a blanket, an insulator, and as such holds heat from the Sun. As the atmosphere moves, it carries the Sun's heat with it. What makes the atmosphere move? There is only one possibility, the Moon. There is nothing else in the sky remotely

composition of the atmosphere

Percentage in dry air	Gas
78.08	N_2 (nitrogen)
20.95	O_2 (oxygen)
0.93	Ar (argon)
0.03	CO_2 (carbon dioxide)
0.0018	Ne (neon)
0.0005	He (helium)
0.0001	Kr (krypton)
0.00005	H_2 (hydrogen)
0.000009	Xe (xenon)

near us. The Moon, by its gravitational pull, directly and daily distributes the Sun's heat around areas of the Earth when it pulls the atmosphere around.

The discovery that the Moon causes atmospheric tides was made in 1939 by two British scientists, Appleton and Weekes, although even to this day, many people are unaware of it. The fact that the atmosphere is moved by the Moon is a key to understanding the weather. How and where the Moon moves determines where the atmosphere goes. When the Moon is over the northern hemisphere, there is more of the atmosphere on that side of the Earth. This does not mean that the southern hemisphere has no air, or everybody would suffocate. It merely means that there is a bulge in the atmosphere, so more of it is on the Moon's side. The Moon gravitationally pulls it because the atmosphere is a movable fluid. Consequently there is *always* an atmospheric bulge following the Moon.

Why is there not an atmospheric bulge equally on the opposite side of the Earth? It is easier to pull air than it is to pull earth. And faster. Yes, air acts as a liquid, but only in the sense that it can be moved around because of its fluidity. Bearing in mind that gravitation has only a pulling effect, the high water tide on the opposite side of

the Earth is caused by the earth floor on the bottom of the oceans being pulled through the centre of the Earth towards the Moon. This leaves a greater depth of water and therefore the high tide on that side. But it's not really a high tide, more a low ocean floor.

When the atmospheric tide is on the other side, the land surface is not pulled at all through Earth's centre towards the Moon to alter the height and therefore the density of the air. Also, with water there is a lag, due to the slowness of water to move against itself. There is not nearly as much (although some) lag with the atmosphere, and as Earth rotates at 1610 km/h (1000 mph) and jet streams can go 800 km/h (500 mph), the Moon takes the bulge with it. Interestingly, the tidal effect acts on solid land too.

The Moon is not spherical but permanently bulged towards Earth – the result of thousands of years of attraction on that side. That is what hastened the Moon to stop rotating, because it was so off-centre. Yet there isn't an equal and opposite bulge on its other side.

The Moon pulls on the solid body of Earth as well as the oceans, which we have already mentioned as causing the bulge on the opposite side of Earth due to the movement of the sea floor. Land tides are easy to measure with suitable instruments.

A rather odd fact emerges. Although the body of the Earth behaves as though it were more rigid than steel, it also proves to be perfectly elastic; after being distorted by the tidal pull it returns to its original shape without any appreciable delay, rather in the manner of an elastic band that it first stretched and then let go.

Land tides, however, amount to only about 11 cm (4.5 inches), and in everyday life they are too minor to be noticed at all.

At perigee the atmospheric bulge of things on Earth towards the Moon is enhanced. After all, the Moon is closer and exerts more pull. Yet there is only so much atmosphere, and when the Moon is on the other side of the Earth, what is left there is changed over the other hemisphere.

Typically the barometer needle will stay unchanged over a day and the following night. Given that there are two atmospheric tides per day,

a high and a low as the Moon makes its transit, this means that although the atmospheric tides change with the phases of the Moon, it won't show on a barometer (which also means an altimeter). If atmospheric pressure doesn't change with the tidal shift, something else must change. We can assume that when the Moon is in the sky gravitation takes over and the atmosphere is stretched, taking the atmosphere to a high tide. We will always have a high tide when the Moon is up. Taking air from wherever, the atmosphere would have to be stretched (molecules pulled out a bit more) to keep the barometric pressure the same as it would be if there were no Moon in the sky. So during a full Moon (night Moon), the barometric pressures having to be the same at night as they are during the day (particularly if there is an anticyclone around), the full Moon 'takes' more of the atmosphere to be above the Earth, creating a higher tide.

During the (full Moon) daytime, then, is the lower tide. With the low tide comes a compactness, a pressurising, lower down. A low-pressure system may accompany it. At full Moon night, there's more air above the Earth, which means more *of* it to keep the pressures the same. To get that effect the Moon must gravitationally hold the atmosphere up, which means it must stretch it out.

A high atmospheric tide means that the molecules are not so closely bonded low down, and the spread of their density is more uniform. During a low atmospheric tide, when the Moon is not above the horizon, the air is more compact lower down and becomes denser, mainly at low altitudes around sea level. At high altitudes, like mountain tops, air will be sparser at the low atmospheric tide because when you get higher and the temperature drops down, the air gets heavier and cold air falls. This creates what pilots would interpret as aviation instability.

Another way to look at it is that a low *sea* tide means the fluid is not as high. When applied to the air, this can actually be seen in the sky. Clouds descend lower in a low atmospheric tide and remain higher in a high tide. You only get real cumulus cloud – those rain-gathering low-down puffy white-gray clumps – when there is no Moon up.

To summarise what is a rather difficult concept to grasp, much less

to prove, a low atmospheric tide results when the Moon is below the horizon, between moonset and next moonrise. The air is compacted, colder, heavier lower down but thinner at higher levels, allowing the cold of space through. At high atmospheric tide, the Moon is above the horizon and the atmosphere is not only stretched higher, it is of more uniform density.

A proof *may* be found in Antarctica. The air is so dense there around ground level that sounds carry for up to a kilometre. Why? Because being colder the air falls and compacts, and sounds travel further through a denser medium. But above ground the atmosphere is less in volume (due to less gravitational pull from the Sun and Moon which are in the plane of ecliptic) than it is at the equator. As the Antarctic atmosphere is virtually narrower in height, the cold of space penetrates almost to ground level, freezing everything all year around. This is why the poles will never melt.

These tides in the atmosphere have some effect upon radio reception. Before satellites were employed, long-distance radio communication was made practicable by the presence of reflecting layers in the upper part of the atmospheric blanket, known as the ionosphere. Researchers showed that reception was best when the Moon, Earth and Sun were in a straight line (either full or new Moon).

What is the role of the atmosphere? The atmosphere keeps two things at bay – the intense searing heat of the Sun and the murderous cold of space. Wherever the atmosphere starts to narrow, either of these two can enter more easily. Through the lower tides of the atmosphere, the cold of space descends and if rain is about, causes greater condensation of water droplets so that the rain falls. Since air behaves nearly as an ideal gas, and vertical distance is proportional to volume over a specified surface area, the thickness between two pressure levels is proportional to the mean temperature of air between those levels. So a lower, compacted air-tide would mean relatively colder air.

That's why the Moon, say, over the northern hemisphere could bring bad weather news for the southern hemisphere. But it goes both ways. A shorter atmosphere also offers less resistance to the Sun. With less

protection from the Sun's fierce heat, heat waves can ensue in summer, while increased cold in winter can mean snowfalls and storms at night when the Sun is no longer in the sky to warm the ground. That is why a low atmospheric tide effect is common at new Moon time and at night, when the Moon is on the opposite side of the Earth. When the Moon is in the sky, there is less likelihood of rain.

As already mentioned, it matters where the full or new Moon is, that is to say, which hemisphere the full Moon is over. The full Moon shifts hemispheres from summer to winter. During the southern hemisphere winter, the full Moon is over the south, and over the north for the northern winter. So when the full Moon is over the northern hemisphere during the southern summer, the southern hemisphere experiences a greater atmospheric tide effect. The bulge in the atmosphere will be over the north, leaving the south with an atmosphere that is narrower. That is why a full Moon in the southern hemisphere generally brings either rainier conditions or more oppressive humidity. The new Moon is the opposite case. It will be over the southern hemisphere in its summer but over the northern hemisphere in its winter, therefore over the opposite hemisphere to the one experiencing winter.

Games organisers might one day take note of this. Sporting events held in the afternoons, between full Moon and last quarter (when the Moon is out of the sky), at higher altitudes especially, invite increased risk of heat exhaustion because of the extra heat coming through the narrower band of atmosphere. Any high-energy event such as a marathon should be held in the early morning of this Moon phase.

Clouds, too, play a role in the effect of the atmospheric tide. They trap heat below them. This is often very striking at night. If a cloud layer is present in the winter, it will be much warmer at night than if the sky were clear. If such a cloud layer dissipates, or clear air moves in, the temperature is sure to drop sharply as the ground radiates its heat energy unhindered into space. In a narrower band of atmosphere, when a cloud obscures the Sun, the temperature on the ground may suddenly turn cold. This occurs between full Moon and last quarter.

The Moon acts, too, to monitor the solar wind. Consider the Sun's

role. The Sun is the major source of energy available to the Earth, and about one two-billionth of the Sun's outpouring of energy is intercepted by us. At the time of the new Moon and the first quarter, there is a lower frequency of magnetic disturbance than between full Moon and last quarter of the month. This is because the Moon gets in the way.

As more research was done on the Moon's effect on the magnetic field, it was realised that the Moon shields the Earth from the solar wind at new Moon and that this magnetism decreases four days before full Moon and increases four days after the full Moon. The cause is instability or disturbance in the magnetosphere tail, caused by the entry of the Moon to the Earth's magnetic tail, known to extend out beyond the orbit of the Moon.

It is the geometry of the tail and the Moon's orbital velocity that ensures the disturbance of the neutral sheet the day before the full Moon.

It is now known that subjecting seeds to a magnetic field before planting increases the yield of certain crops. (A Russian company doing this advertises its services via the Internet). Yet many indigenous peoples, including the early Maori of New Zealand, planted just after the new Moon. Presumably this gave the seeds just enough magnetic dosage. Planting later would have been too harsh. The question must be asked, did the Maori discover this by chance or is this knowledge thousands of years old?

With the magnetic field effect established, scientists (Lethbridge and colleagues) analysed thunderstorm frequencies for the United States in relation to the full Moon. During a thunderstorm they measured the electrical potential of a tree and the ground. For several hours before the onset of a storm, the ground measured a positive electrical potential of 60 mV for several hours. The electrodes in a tree showed a 40–50 mV potential. Then, quite suddenly, the positive potential of the ground dropped to zero and became a negative potential of 20–30 mV. As the storm passed, this was reversed and the ground recorded a positive potential again of 60 mV. A very similar change occurred in the tree potentials prior to the storm, with the development of reversed polarity

paralleling the Earth, beginning somewhat sooner and taking a little longer to develop.

One can say planting seeds according to the Moon's phase allows the seeds to experience such electrical field changes.

We always talk about the Sun's heat, but the Moon has a heating effect on us too. In 1995 Robert Balling (of the team John Shaffer, Randall Cerveny and Robert Balling, at Arizona State University) found an influence of the Moon's phase on daily global temperatures. In the course of a lunar cycle it happens that the global temperatures in the lower troposphere (the lowest 6 km of the atmosphere) are warmest about five to eight days before the full Moon and coolest during the new Moon.

During a period of nearly 5934 days (200 synodic cycles) between 1979 and the early months of 1995, the phase of the Moon accounted for a global variation in temperature of about 0.02 – 0.03°C. Maybe not enough to fear getting moonburnt, but it is significant enough to alter weather.

The same team found that the Moon also heats the Earth's polar regions. Using 17 years of satellite temperature data, they found that the poles show a temperature range of 0.55°C during a lunar month. This range of temperature is 25 times greater than for global temperatures as a whole. It shows that there is a strong pole-ward transfer of heat near the full Moon but the transfer weakens near the new Moon.

A study by Kirby Hanson and his colleagues at the National Oceanic and Atmospheric Administration showed a lunar effect on the timing of the maximum spring rainfall in different parts of the United States. It seems that maximum spring rainfall readings occurred progressively later in the synodic month as observed from the West Coast to the East Coast, with a time-shift delay of about 13 days between the two coasts.

what causes **earthquakes**?

Moonquakes do not have the frequency or power of quakes on Earth, but there are about 3000 in the Moon per year, penetrating different layers of the Moon. There is evidence that moonquakes increase when the Moon is closest in its orbit to Earth. Correspondingly, we might expect an increase in earthquakes at that time (the perigee), too. Many think earthquakes are triggered by the Moon in its monthly movement north and south of the equator and its orbit around the Earth. The word 'triggered' is used here because the Moon may pass over a danger point many times until the strain on a fault becomes too great, after which the fault may 'give' in one sudden movement.

Picture a molten mass with overlapping plates floating on it. The tide moves and the plates are jostled. Eventually a tear or gap in the plates forms. The tectonic plates can only be moved about the planet by the Moon's orbit, for without a Moon there would no reason for the plates to move. It is the only regular gravitational attraction that can put steady pressure on such plates to dislodge them.

The main danger times are when the Moon is crossing the equator during the monthly declination cycle. This is the time when the Moon is moving quickly between the hemispheres. When the Moon is at the 28° declination, it will cross the equator twice each month at about 7° in a day, which gives considerable pull on our planet. At 18° it crosses at about 4° in a day and the effect is less positive.

The other danger period is when the Moon is at either of the maximum declination positions north and south of the equator. The Moon is at those positions for about three days and places considerable strain on the tectonic plates while there. It must be remembered that the Moon is always on the move and a quake can happen at any time.

Perigee has a grander tide too. It occurs over each hemisphere in turn. In 1999 it left the southern hemisphere, and will be over the northern hemisphere for about the next four years; while there, it places a greater strain on the tectonic plates of the southern hemisphere, with increased potential for a serious earthquake.

DATE	MAGNITUDE	PLACE	FULL MOON	NEW MOON	PERIGEE	APOGEE
1 Nov 1906	7.8	West Coast, USA	Same day			2 days before A
3 Feb 1931	7.9	Napier, NZ	Same day		Same day	
18 May 1940	7.7	Imperial Valley, USA	3 days before F		Same day	
21 Jul 1952	7.7	Tehachapi, USA		Same day		2 days before A
27 Mar 1964	8.4	Anchorage, Alaska	Day before F			5 days before A
19 Aug 1966	6.9	Turkey		3 days after N	2 days after P	
11 Feb 1975	7.5	Guatemala		Same day		Day before A
11 Jan 1977	7.3	Michoacan, Mexico		2 days after N	1 day after P	
23 Jan 1977	7.1	Juy Juy, Argentina	Same day			2 days before A
11 Mar 1977	7.0	Mindanao, Philippines		2 days after N	2 days after P	
21 Apr 1977	7.9	Santa Cruz Is	Day before F			3 days after A
14 Oct 1977	7.7	Fiji Is, Pacific	Day before F		Same day	
14 Oct 1977	7.0	Chile, Central Coast	Day before F		Same day	
28 Oct 1977	7.2	Peru		3 days before N		Day before A
22 Jan 1988	7.0	Tennant Cr, Australia		2 days after N	2 days after P	
4 June 2000	7.9	Sumatra, Indonesia		2 days after N	2 days after P	

G. A. Eiby, in his 1980 book *Earthquakes*, listed major earthquakes dating back to 1505. I looked at each date with regard to Moon phases: 96 per cent of the quakes occurred exactly on or within a day of an extreme feature of Moon cycle (new Moon, full Moon or perigee) and 75 per cent involved two factors (when the perigee plus full or new Moon were on the same day).

The *apogee* (the point at which the Moon is farthest away in the month) keeps appearing as a factor too. Why, if the apogean Moon exerts *less* gravitational force, does it pull equal to perigee on tectonic plates? I am of the opinion that in apogee the Moon covers a wider area of Earth as it crosses the equator, because the precession angle combines with the farther distance. The Moon then has a greater 'swing' between declination points, sometimes adding up to an extra trajectorial degree. Any plates 'due to go' at the edge of the Moon's orbital influence could receive a final push. But also, perigee and apogee in space are like up and down: they are both relative to each other, both opposites of each other, and both exert an equal degree of influence. Declinations north and south also match equally.

Precession angle, declination points? We are getting ahead of ourselves. We should look first at perigees more closely.

perigees and apogees

To most people every full Moon is alike – the rising or setting Moon looks large because the perspective is playing tricks on the eye, and most assume that the full Moon high in the sky is always the same. A spectacular phenomenon escapes notice simply because the eye and brain can't compare the size and brightness of objects observed on separate occasions. The full Moon varies dramatically in apparent size and intensity but hardly anybody notices.

As the Moon travels anticlockwise around the Earth, orbiting the same way as the Earth while both go around the Sun, its orbit is not a perfect circle. That would indeed be a marvel! Hence it does not remain a constant distance from the Earth. This was discovered by the Greek

astronomer Hipparchus (second century BC), so it is by no means a new discovery. He realised that the Moon wanders in and out, towards the Earth and away again, as if the Moon were on a fixed spring, for the outer limit is relatively fixed and varies much less than the inner.

This cycle is called the apogee–perigee cycle, and we say that the Moon's orbit around the Earth is elliptical, that is to say, off-centre (like a circus-bicycle wheel). It has a substantial eccentricity (as major solar system bodies go) of 5.49 per cent. In addition, the tidal effect of the Sun's gravitational field increases this eccentricity when the orbit's major axis lines up with the Sun–Earth vector or, in other words, the Moon is full or new.

The combined effects of orbital eccentricity and the Sun's tides result in a substantial difference in the apparent size and brightness of the Moon at perigee and apogee. Apogee is generally about 404,500 km (252,700 miles) from the centre of the Moon to the centre of the Earth. Compare that to a typical perigee of 359,000 km (221,500 miles). So from when the Moon is most distant from the Earth, to when it is at its closest point, there is a difference of about 50,211 km (31,200 miles).

The changes in distance are quite considerable, and the Moon's apparent diameter at apogee is only nine-tenths of the value at perigee.

The difference is sufficient to add 20 per cent to a high sea tide when the Moon is at perigee, for this is when the Moon's gravitational attraction is at its strongest. But the difference is not marked enough to be noticeable with the naked eye. If this off-centre orbit of the Moon were drawn to a scale of, say, three inches in diameter so that it could be fitted onto a page of this book, it would look circular unless carefully measured.

Although extreme values for perigee and apogee distances occur when perigee or apogee passage occurs close to new or full Moon, long-term extremes are in the months near to Earth's perihelion passage (closest approach to the Sun, when the Sun's tidal effects are strongest) in the first few days of January.

perigee and apogee

sense of scale

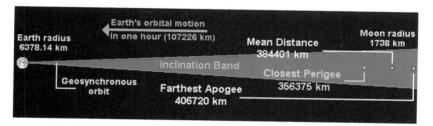

Earth radius
6378.14 km

Earth's orbital motion
In one hour (107226 km)

Moon radius
1738 km

Mean Distance
384401 km

Inclination Band

Geosynchronous
orbit

Farthest Apogee
406720 km

Closest Perigee
356375 km

The preceding photographs show how strikingly different the Moon is at a full-Moon perigee and apogee. Most people don't notice the difference because they see the Moon in a sky that offers no reference by which angular extent may be judged. To observe the difference, you have to either make a scale to measure the Moon, or else photograph the Moon at perigee and apogee and compare the pictures, as has been done here.

When *Apollo 11* Commander Neil Armstrong walked on the Moon on that historic day of Monday 21 July 1969 this date had been taken into account by the NASA planning team months before. The day of the perigee for that month was 28 July, leaving them with a few days spare. The Moon was sitting at 357,925 km away. Why wait for a perigee? To save fuel! Why stack on board more weight than you have to? Especially 31,000 miles worth!

The fact that it was July was significant too. This was no ordinary perigee, but the greatest for the year, saving the project an extra 10,000 km of travelling distance than if they had chosen any other month than July (or June) in that particular year. Had they waited till, say, the October perigee, the astronauts would have had to travel 12,000 more kms (7500 miles).

When we gaze at the Moon on a still full Moon evening we think of it as being very bright but it is really no brighter than asphalt. Next time you see the full Moon rising just after sunset, try to position yourself so you can see it alongside a stone wall. You will see that the Moon is no brighter than the appearance of stone in full sunlight. This is yet another illusion and due to the fact that we see the Moon against a dark sky.

When it's a full Moon near perigee, you'd expect it to be brighter than a full Moon near apogee and it is – lots brighter! Since the Moon shines by reflecting sunlight (it reflects only about seven per cent of the light that strikes it, about the same as a lump of coal) the following two factors determine the intensity of moonlight at the Earth: the intensity of sunlight striking the Moon and the distance that reflected light travels from the Moon to the Earth.

Because the difference between the minimum and maximum distance of the Moon – 50,345 km – is an insignificant fraction of the average distance from the Sun to the Earth and Moon – 149,597,870 km – the intensity of sunlight at the Moon can be considered constant and ignored in this calculation. (Sunlight intensity at the Moon does vary, of course, because of the eccentricity of the Earth's orbit around the Sun, but we'll ignore that smaller annual effect while we're concentrating here on lunar perigee and apogee.)

The intensity of light varies as the inverse square of the distance between a light source and the observer. Taking the ratio between the perigee and apogee distances in the photographs above as typical, the distance at apogee was 1.1363 times the perigee distance, and hence the Moon's intensity at perigee was the square of this quantity, 1.2912 times brighter – about 30 per cent.

Like the variation in angular size, few people ever notice this substantial difference in the intensity of moonlight at perigee and apogee because there's no absolute reference against which to compare them. If you could flick a switch and move the Moon back and forth between apogee and perigee, the difference would be obvious, though not as evident as you might expect from a 30 per cent change in illumination due to the logarithmic response of the human eye.

The Moon brightens dramatically when full – interestingly, it is more than *twice* as bright at the moment of fullness than only two days before or after.

It may have been noticed that the two images of the Moon in the photographs differ not only in size but also in the position of features on the disc of the Moon. This might seem puzzling in light of the frequently-stated assertion that the Moon always keeps the same face towards the Earth. But this generalisation is not strictly true; in fact, the combination of the eccentricity and inclination of the Moon's orbit causes the Moon, as seen from the Earth, to nod up and down and left and right.

These apparent motions, the lunar librations, allow us to observe, over a period of time, more than 59 per cent of the Moon's surface from the Earth, albeit with the terrain in the libration zones near the edge of the visible disc only very obliquely. In other words, we really see more than half the Moon's face.

When the Moon is south of the ecliptic due to its position along its inclined orbit, observers on Earth at that time are looking down onto the Moon's north pole, with the Moon's equator appearing below the middle of the visible disc. While the Moon is, at that moment, south of the equator as seen from Earth, an observer in our northern hemisphere is additionally displaced northwards and can see further past the north pole of the Moon.

At the time of the apogee photo, the situation was the opposite; the Moon was both above the ecliptic and 22° north of the celestial equator. Consequently, observers on Earth saw the south pole of the Moon tilted towards them, with the lunar equator displaced towards the northern limb of the Moon.

Why does this happen? When the Moon is closer to the Earth, around perigee, its orbital motion is faster and carries it past the Earth faster than its constant rotation speed. But when the Moon is near apogee, its slower orbital motion causes the rotation to get a bit ahead of the orbital motion, revealing terrain on the other side of the mean limb.

The mean distance to the Moon, 384,400 km, is the semi-major axis of its elliptical orbit. The closest perigee in the years 1750 through to 2125 was 356,375 km on 4 January 1912. The most distant apogee in the same period will be 406,720 km on 3 February 2125. In reality, extreme perigees and apogees always occur close to a new or full Moon.

The mean distance is not equidistant between the minimum and maximum because the Sun's gravity perturbs the orbit away from a true ellipse. Although the absolute extremes are separated by many years, almost every year has a perigee and apogee close enough to the absolute limits.

Apogee and perigee are not on the same day each month, but if you kept a running record you would discover that 8.85 years is the exact length of the apogee–perigee cycle. Of that time, half (approximately four years) is spent over one hemisphere and half over the other. Whatever hemisphere the perigee is over will generally be subject to more inclement weather around the globe during the perigee duration.

The Moon speeds up and slows down at different rates in the four weeks from one perigee to the next, moving at its greatest speed when it is at perigee and at its slowest when farthest from the Earth at apogee. The Moon's speed is also affected by the lunar phases, because the Sun's pull on the Moon is different in the various lunar quadrants. For instance, the Moon moves faster from the last quarter to the new Moon, and slower from the new Moon to the first quarter. It also speeds up from the first quarter to the full Moon and slows down from the full Moon to the last quarter.

in **fishing**

It was important for Maori to know when perigee occurred because it affected the fishing. At perigee the extra gravitational effect whips up the tides and the weather, causing higher tides and rougher seas. Fish do not come near the shore at this time because the churning of the sea near the shallows causes sand to get in their gills. So the fishermen would stay home. Besides, it was safer.

But at apogee, when the Moon is far away, therefore having less pull, the conditions are calmer and the fish swim closer to the land. The Maori fishing calendar is apogee-driven, and it makes good sense. Fishermen will tell you, even today, that fish bite better a couple of days just before a storm. A storm is usually perigee-driven and the fish are soon going to have to swim farther out where food supply is scarcer. So after the storm they will be back, and hungry. It'll be good fishing then.

The Maori priest (the tohunga) in charge of fishing had to know in advance. It was not uncommon for the fishing tohunga to be put to death if he was wrong. When the Moon was in perigee was secret knowledge, passed from teacher to apprentice.

How did the early Maori know when it was perigee? They used a measuring stick to determine when the Moon was closest. It is simple enough to run your thumb along a stick with the arm outstretched, and measure the size of the Moon (whenever it was visible) around that month. Add two weeks or 14 days and you have the apogee. Go a couple of days each side and you know when it is best to fish and when you can expect poor returns. So simple when you think about it.

In Europe it was believed there were parallels in the way the Moon orbits around the Earth and the way the Earth orbits around the Sun. Full Moon was compared to summer and the new Moon in its darkness to winter. Emergence from the new Moon was regarded as a spring-like renewal, whereas last quarter suggested a mini-autumn. At Christmas time the Sun stands at its lowest point against the background of the Archer.

There is some truth to this with regard to weather, even if it appears a little whimsical. The best climatic conditions for the month are more likely to be new Moon to first quarter, whereas thunderstorms and lightning are more common around last quarter.

in **planting**

The effect of plant growth during apogee was traditionally compared to the time of year when the Earth is farthest from the Sun.

For	Time of cycle	Background	Event	Effect
SUN	Christmas	Archer	Winter solstice	Day shortest length, starts getting longer
	Easter	Fishes	Spring equinox	Day and night equal length
	Midsummer		Summer solstice	Longest day, shortest night
	Michaelmas		Autumn equinox	Day and night equal length
MOON	Lowest point	Archer		Plant forces start getting stronger
	Highest point	Twins		Greatest growth point, plant now begins orienting itself more towards the root

The tendency in the plant world is to run to seed, while the growth forces decrease. This more settled nature is reminiscent of midsummer. Thus the effect of the Moon's apogee on *seed* plants can be beneficial, giving settling time in the soil without the toing and froing of the soil's fluids.

For the sowing of leaf crops, however, this time is definitely unfavourable. Carrots sown during these days easily become woody. The only leafy plant to react positively to being sown at apogee is the potato.

But the Moon's perigee, which can be compared to a midwinter with the Earth nearer to the Sun, has a very different effect. For seed plants, germination is poor; most of these plants are inhibited in their growth and are also more subject to attacks from fungus diseases and pests. Apogee days are mainly clear and bright, whereas those at perigee are mostly dull, heavy or rainy. These principles remain in force today as the basis for biodynamic gardeners who plant by the Moon.

comparing cycles

The perigee–apogee cycle alternates every four years, as can be seen in the next table of perigees. Every four years, perigee also changes hemispheres. As can be seen, perigee dates for 1991 nearly match those in 1995; those in 1992 nearly match those in 1996, and so on.

Is there a cycle that takes into account both the new–full Moon and perigee–apogee cycles, such that the Moon exactly repeats itself in both of these ways? Yes, every 133 years!

Compare the tables on pages 92–93 for the years 1730, 1863, 1996 and 2129 (each 133 years apart) to find parallels for dates of phases and perigee–apogees.

Uncannily, the parallel days are no more than three days out in 400 years. But are *all* years close to that pattern? Definitely not. Look at the first few dates for, say, 1978 on page 94. They are way out.

The alert reader would have noticed that 133 is exactly 19 x 7, in other words 7 exact 19-year lunar cycles. The Greek astronomer Meton discovered this 19-year cycle in 432 BC, and it still bears his name. The Metonic Cycle can still be used today. Every 19 years to within 24 hours, Moon phases repeat. That is, 235 29.5 day lunations.

But before plunging immediately into long-range forecasting by looking up the weather 19 years ago, to the day, be warned that it is not 100 per cent accurate. After only 19 years the Milky Way moves north a fraction, followed by a little more over the next 19. Eventually after 133 years everything returns exactly to its original position. A forecast based on a 19-year turnaround will be correct only part of the time.

So if we had the records for 133 years ago, because the constellations and planets also repeat to the day, would we have a fail-safe system? Before we look harder at forecasting, we need to examine how the Moon moves with respect to the Earth.

dates of the perigee

	1991	1992	1993	1994	1995	1996	1997	1998	1999	2000	2001
JANUARY	28th	19th	10th	6th/31st	27th	19th	10th	3rd/30th	26th	19th	10th
FEBRUARY	25th	17th	7th	27th	23rd	17th	7th	27th	20th	17th	7th
MARCH	22nd	16th	8th	28th	20th	16th	8th	28th	20th	14th	8th
APRIL	17th	13th	5th	25th	17th	11th	5th	25th	17th	8th	5th
MAY	15th	8th	4th/31st	24th	15th	6th	3rd/30th	24th	15th	6th	2nd
JUNE	13th	4th	25th	21st	13th	3rd	24th	20th	13th	3rd	23rd
JULY	11th	1st/30th	22nd	18th	11th	1st/30th	21st	16th	11th	1st/30th	21st
AUGUST	8th	27th	19th	12th	8th	27th	19th	11th	7th	27th	19th
SEPTEMBER	5th	25th	16th	8th	5th/30th	24th	16th	8th	2nd	24th	16th
OCTOBER	2nd/27th	23rd	15th	6th	26th	22nd	15th	6th	26th	19th	14th
NOVEMBER	24th	18th	12th	3rd	23rd	16th	12th	4th	23rd	14th	11th
DECEMBER	22nd	13th	10th	2nd/30th	22nd	13th	19th	2nd/30th	22nd	12th	6th

Year 1730	Perigee	Apogee	New moon	Full moon	Declination (fm rising)
JANUARY	17th	1st/29th	18th	4th	59.8° (E of N)
FEBRUARY	14th	26th	17th	3rd	69.7°
MARCH	12th	25th	18th	4th	81.9°
APRIL	6th	22nd	17th	3rd	99.9°
MAY	4th	20th	16th	2nd	109.8°
JUNE	1st/30th	16th	15th	1st/30th	122.2°/120.9°
JULY	28th	13th	15th	29th	113.8°
AUGUST	25th	10th	13th	28th	96.1°
SEPTEMBER	22nd	6th	12th	26th	83.8°
OCTOBER	17th	4th	11th	25th	72.1°
NOVEMBER	13th	1st/29th	10th	24th	57.7°
DECEMBER	11th	26th	9th	24th	57.7°

Year 1863	Perigee	Apogee	New moon	Full moon	Declination (fm rising)
JANUARY	18th	3rd/30th	19th	5th	61.8° (E of N)
FEBRUARY	15th	27th	18th	3rd	71.5°
MARCH	15th	27th	19th	5th	83°
APRIL	9th	24th	18th	4th	101°
MAY	6th	22nd	17th	3rd	109°
JUNE	3rd	18th	16th	1st	113°
JULY	1st/30th	15th	15th	1st/30th	114°/108°
AUGUST	27th	11th	14th	28th	99.1°
SEPTEMBER	24th	8th	13th	27th	81°
OCTOBER	20th	6th	12th	26th	72°
NOVEMBER	15th	3rd/30th	11th	25th	64°
DECEMBER	12th	28th	10th	25th	63°

Year 1996	Perigee	Apogee	New moon	Full moon	Declination (FM RISING)
JANUARY	19th	5th	20th	5th	66° (E of N)
FEBRUARY	17th	1st/29th	18th	4th	72°
MARCH	16th	28th	19th	5th	84°
APRIL	11th	24th	17th	4th	97°
MAY	6th	22nd	17th	3rd	105°
JUNE	3rd	19th	16th	1st	110°
JULY	1st/30th	16th	15th	1st/30th	112°/100°
AUGUST	27th	12th	14th	28th	100°
SEPTEMBER	24th	9th	12th	27th	85°
OCTOBER	22nd	6th	12th	26th	76°
NOVEMBER	16th	3rd	11th	25th	67°
DECEMBER	13th	1st/29th	10th	24th	65°

Year 2129	Perigee	Apogee	New moon	Full moon
JANUARY	20th	6th	20th	5th
FEBRUARY	17th	2nd	18th	4th
MARCH	17th	1st/29th	20th	6th
APRIL	13th	24th	18th	4th
MAY	8th	26th	18th	4th
JUNE	5th	24th	16th	2nd
JULY	3rd/31st	18th	16th	2nd/31st
AUGUST	29th	14th	15th	29th
SEPTEMBER	26th	10th	13th	28th
OCTOBER	24th	8th	13th	27th
NOVEMBER	19th	5th	11th	25th
DECEMBER	14th	3rd/30th	11th	25th

Year 1978	Perigee	Apogee	New moon	Full moon
JANUARY	8th	21st	9th	24th
FEBRUARY	5th	17th	7th	23rd
MARCH	5th/31st	17th	9th	24th
APRIL	26th	12th	7th	22nd
MAY	24th	24th	7th	4th

the monthly wobble

Many people think the Earth is in space, like the picture below. But it's really more like the picture on the next page.

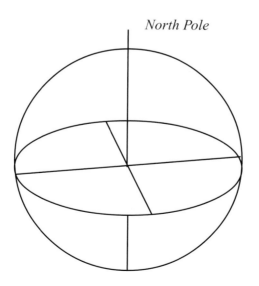

North Pole

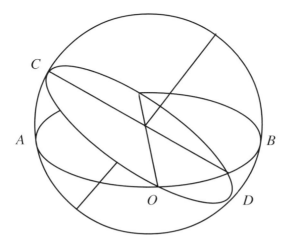

Imagine if you will, that AB is a ball, with a spinning top called CD, spinning inside it around the direction of C, then out of the page towards your chest and then on to D and around again. Imagine the inner spinning top is the Earth.

For this is what it looks like. CD is the Earth's equator. BOD is the Earth's tilt. The Earth slides around the Sun in the plane of AB, tilted all the while. It's this tilt, CD as compared to AB, about 23.5° (measured through BOD), that gives us our seasons, because the parts of the Earth at any one time leaning closer to the Sun are having their summer. The tilt always tilts the same way, which means the Earth spends six months on one side of the Sun and six months on the other. This tilt is slowly changing, which means our seasons are getting longer. It varies between 21° and 24°, taking 42,000 years for that little variation!

Most satellites that are close to their planets, as our Moon is, revolve in their planets' equatorial planes, so we might expect the Moon to go around us at CD. But not this moon! Our satellite ignores the Earth's equator and swims merrily along in the same plane around the Sun as the Earth does, which is AB (the ecliptic plane). That is because it is more influenced by the Sun and therefore its orbit around the Sun, than it is by the Earth and its orbit around Earth.

But the Moon's movement around AB is *not in a flat plane*. Have you ever held a dinner plate just above a table, given it a slight turn and dropped it? If it doesn't break, it hits the table and wobbles round and round as it settles on the table surface. If you can imagine circle AB having a wider circle around it – that would be the Moon's orbit – then this wider-circle/Moon's-orbit behaves just like a wobbly dinner plate. While AB is steady, the wider circle wobbles heavily around it.

How much does it wobble up and down with respect to AB? Assuming we take our reference point as the plane of AB, it varies a maximum of 5° above and then 5° below the ecliptic (the plane of AB, its orbit plane around the Sun) on the opposite side of the Earth, crossing the equator as it goes around one cycle of AB. That takes a month. For two weeks it is above AB and for the next two weeks it is below AB. This wobbly action has nothing to do with the full/new Moon phases or the perigee/apogee. It is a separate cycle, called the monthly declination cycle.

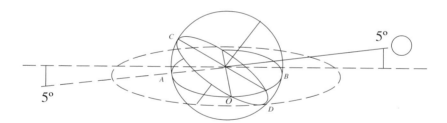

So once a month the Moon is high, or northern, and once a week it hits a southern point. Also, twice a month it crosses the equator – once going from southern declination point to northern, and once going from northern declination point to reach the southern point in its travel. How does it affect the weather?

When the Moon peaks at its northern monthly declination *or* its southern monthly declination, the weather can be said to be *slow-moving*, because the Moon is moving parallel to the Earth's rotation and things are held relatively steady for two or three days. This applies

to good weather or bad. The weather bureau used to call this slowing-down a 'blocking' system, as if something were preventing any faster movement. But nothing is being 'blocked'.

This happens twice-monthly. Then the Moon starts to plunge down or up from its declination points, moving faster as it crosses the equator at AB. As it moves past AB it tends to cause weather to be changeable as it is faster moving. Looking at weather maps will confirm this.

Whatever weather is around at the time of northern or southern declinations, will last three or four days, whereas weather occurring when the Moon is crossing the equator cannot be trusted to last for too long.

Most disasters are more likely to occur when the Moon is in the opposite declination to where you happen to be. If the Moon is up at its northern point, the southern hemisphere gets bad weather; and at southern declination point, bad weather is more likely in the northern hemisphere. This also has something to do with the atmospheric tide effect (see the next chapter).

Look at the weather chart for the week commencing 24 January 1999. (P: perigee, F: full Moon, A: apogee)

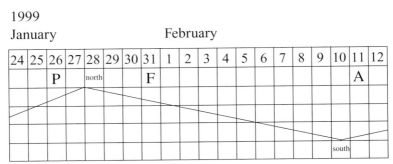

This was the week of a devastating earthquake in western Colombia, where more than 1000 people died. The date of the disaster was 26 January 1999, exactly on the perigee. Three factors, all Moon-related, are in evidence here.

The perigee can be relied on to cause trouble, and its proximity to the full Moon for that month increases the gravitational effect of the Moon upon the Earth. But your attention might also be drawn to the fact that the Moon is near the northern declination on the date. As you can see, it would add to the fuss. It means that the Moon was already 'over that way', actually almost directly overhead at the time.

Almost to the month on another full Moon day early in 1812 there was another earthquake in the same area; Columbia, Venezuela. That was 187 years before, which, being nearly 18.61 x 10, represents ten maximum-declination or nodal cycles. We will look at what *they* are in the next chapter.

Let's look at another earthquake, this time the gigantic Napier earthquake in New Zealand, on 3 February 1931.

1931
January February

24	25	26	27	28	29	30	31	1	2	3	4	5	6	7	8	9	10	11	12
							north			P/F								A	
																			south

Once again, a major quake occurred within a day or two of the northern declination for that month (January).

The position of the Moon's monthly declination seems to seriously affect most weather. It's not just earthquakes; thunderstorms, tornadoes, tsunamis, cyclones, hurricanes and floods are all part of the same process of increased gravitational pull.

When we are looking at a weather map, we want to know the direction of the weather; that is, whether or not an anticyclone (fine weather) that might be sitting north of the country at present will pass over our country or skip by us.

So here are two simple rules.

- If the Moon is at either its northern or southern monthly declination points, the weather situation will remain as it is for a few days. Mostly, *the weather will move at this time along the latitude lines.* This situation persists for a couple of days on either side of the declination point. Therefore, if the anticyclone in question is north of us, it will stay north and go slowly from west to east. Winds will be mainly westerlies.

- If the Moon is *not* at either the northern or southern declination point but is crossing the equator (that is, as it goes from its northernmost point towards the south, or vice versa), it drags anticyclones with it in the same direction. So if the anticyclone is north of us and the Moon is travelling between north and south, the anticyclone will be pulled by the Moon down across the country on a diagonal *across the latitude lines.* On the weather map this will be south-west up to north-east when the Moon is travelling to its northern point, and north-west to south-east when the Moon is travelling towards the southern declination point.

The monthly cycle of lunar declination contributes to the overall tidal effects. The closer the Moon comes to being overhead, the more powerful are its effects. The greatest possible astronomical tide-generating force occurs when, at the same time, the Sun is at its perigee, the Moon is at full or new Moon, and both the Sun and Moon have zero declination. This happens about once in 1600 years. It happened in 250 BC and AD 1400, and it will occur again around AD 3300.

To recap, the Moon seems to rise in an easterly direction and set in the west, due to the rotation of the Earth from west to east. Because the Earth rotates faster beneath the Moon than the Moon moves through the heavens, we tend only to notice the nightly east–west passage. Watching over a few days, however, would tell you that it rises about 48 minutes later each successive night, because during the time the Earth has rotated, the Moon has shifted slightly eastward in its monthly orbit around us. Travelling eastward, it covers an average of 13.29°

per day, as it goes faster during perigee (14.73° daily) than at apogee (11.85°). The path of the Moon is not very different from that of the Sun; the angle between the two paths is only 5° which doesn't seem very much, but it's sufficient to prevent eclipses occurring every month. The Moon's monthly wobble takes it around the Earth from a northernmost point to a southernmost point in 14 days; and then back again.

Syzygy is the name given to the situation whereby the centres of the Sun, the Earth and the Moon lie along a common line. One of the most devastating East Coast coastal storms on record in the USA took place during 5–8 March 1962. The new Moon, perigee, and the lunar equatorial declination (the Moon crossing above the equator midway between northern and southern declinations) combined on 6 March 1962. When the Moon is over the Earth's equator (as in the months of the spring and autumn equinoxes), the amplitudes of morning and night-time tides are the same. In March 1962, five successive high tides came in the category of super-elevated perigee spring tides of nearly equal magnitudes. The storm centre became blocked so that the high winds kept blowing, at a time when higher-than-normal astronomic tides of equal magnitude were moving in and out. The result was huge and widespread destruction.

There is a large electrical factor, too, in violent storms. The Moon is magnetically locked to the Earth. Surges in the magnetic field cause inductive heating in the core and mantle of the Earth. Increases in the global magnetic fields add energy to hurricanes that are moving to the mid-latitudes, in synchronisation with the lunar equatorial crossings (north or south). In other words, if there is a storm brewing around the middle band of the Earth, and the Moon is crossing the equator at that moment, the storm will be magnified.

Imagine that a wobbling dinner plate settles a bit, so it nearly flattens out, and then as you watch, it slowly rises up again into a bigger wobble. You keep watching and you see it settle back down again, only to rise again later and repeat the pattern. It's almost as if it is on an expanding and contracting screw-thread.

It is this variation in the wobble that produces the so-called greenhouse effect, global warming, El Niño, and La Niña patterns. The scientific community is currently in a tizz over these words. But since 1863 the planet's temperature has risen about one degree, and so far the effects have not been too catastrophic.

No, the Earth is not anywhere near heating up to furnace point, the poles aren't melting, we won't suffocate to death because aerosols are destroying all the oxygen, nor are motor cars killing the planet. We should curb pollution that messes up our immediate environment, but there is nothing to panic over. When one realises what the Moon is doing, it is clear that its cycles are predictable. It has been moving from one end of its cycle to the other for thousands of years; and the weather has followed suit.

maximum declination and the **18-year cycle**

We have looked at how a spinning and wobbling flat dinner plate might settle a bit so that it nearly flattens out and then slowly rises up again into a bigger wobble, only to settle back down a bit and repeat the process.

Imagine that on the edge of such a spinning plane sits the Moon. For each monthly declination, we pictured the Moon starting on AB as a reference point and going around while dipping below, and then around further and coming back up to the beginning again. It does this month in and month out, year in and year out.

We can think of it starting around AB. Let's call this the low point. The Moon wobbles around the Earth all year, 12 times. After each year of monthly cycles, it has slowly, by 1°, risen up into a slightly bigger wobble – still crossing AB to go underneath, still circling the Earth once per month with a northern and southern declination and two equatorial crossings. But its *range* of movement is now slightly more than it was last year.

On page 105 you'll see that BOD is already around 18° at low point, because the tilt of the Earth is about 23.5° and the Moon's angle 5° (actually 5.145396); and 23 − 5 = 18. The Moon's monthly wobble increases by a degree per year. The last low point was in March of 1997, and the last high point September 1987 (which caused the Midwestern drought of 1987–91), which is when scientists coined the term 'Greenhouse Effect'. As 1° is added to the monthly wobble per year, and the maximum is 5° added, the maximum declination is around 28° (23+5).

How long does it take to work itself up into a larger wobble? Well, at 1° a year, after five years it is about 5° above AB (and of course 5° below as well, 14 days later). Because AB was the low point, it was where we were two or three years ago. That 18° mark is called the minimum declination point. That means that from the minimum declination point to the higher-wobble mode of *maximum declination* takes about nine years. We will be at the upper level in March 2006. The whole cycle takes 18.6 years. In other words, 223 (12 x 18.6) wobbly monthly orbits is the whole cycle.

As seen from the centre of the Earth, the Moon drifts up and down slightly *more* than 5° in the course of each orbit. That's because the Earth swings a little too, due to the Moon's pull on Earth, rather like two square dancers who grasp hands and swing each other in a circle. The result is that when travelling north or south across the node points the Moon lags behind the ecliptic by about 5°, catching up with the ecliptic again at the northern and southern declinations.

This 18-year cycle is very important, and at the risk of boring the reader, I will explain it again. The Earth is tilted up already, by 23.5°. An extra 5° is added or subtracted from the 23.5, making 18° at the low end of the cycle and about 28° at the high end about nine years later. As you look at the diagrams below it may become clearer. The Moon is pictured in two positions: the lower at 18.5° (23.5 − 5), and the higher at 28.5° (23.5 + 5).

You can see that the sphere of influence which the Moon has changes throughout the 18-year declination cycle.

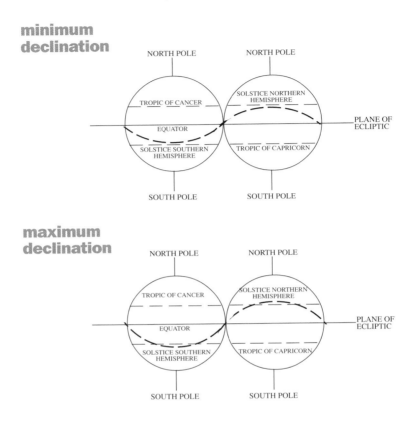

minimum declination

NORTH POLE · NORTH POLE

SOLSTICE NORTHERN HEMISPHERE

TROPIC OF CANCER

PLANE OF ECLIPTIC

EQUATOR

SOLSTICE SOUTHERN HEMISPHERE · TROPIC OF CAPRICORN

SOUTH POLE · SOUTH POLE

maximum declination

NORTH POLE · NORTH POLE

SOLSTICE NORTHERN HEMISPHERE

TROPIC OF CANCER

PLANE OF ECLIPTIC

EQUATOR

SOLSTICE SOUTHERN HEMISPHERE · TROPIC OF CAPRICORN

SOUTH POLE · SOUTH POLE

Fortnightly changing hemispheres, the Moon ranges over a fairly narrow band of the Earth's surface between the tropics at the 18° end. But it ranges so widely at the 28° end that it covers parts of the Earth's surface nearer the polar regions.

The declination of a star does not change much in a human lifetime. However, the declination of the Sun and the Moon change from day to day. The Sun throughout the year always has the same declination values. For example, at the summer solstice the Sun will always have a declination value of about +23.5°. At the winter solstice, it will be –23.5°. At the equinoxes, the value will be 0°.

minimum declination

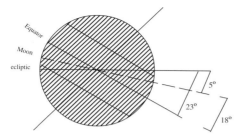

maximum declination about nine years later

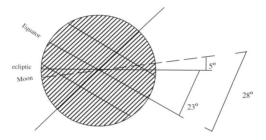

For the Moon, during the maximum declination, the midwinter full Moon will have a declination of about +28°, and the midsummer full Moon will be about –29°. The minimum declinations are about +18° and –19°. Yet these, of course, are modern values. It's interesting to compare prehistoric declinations.

sun's declination at the solstices

4000 BC	24.1°
3000 BC	24.0°
2000 BC	23.9°

position of the moon

	MAXIMUM	MINIMUM
4000 BC	+28.4°/–30.2°	+18.1°/–19.8°
3000 BC	+28.3°/–30.1°	+18.0°/–19.7°
2000 BC	+28.2°/–30.0°	+17.9°/–19.6°

This is evidence that values of the solar and lunar extreme positions have changed slightly over the centuries, because of the precession of the equinoxes – the top-like wobble of the Earth as it spins on its axis. The wobble has been caused by the Moon's gravitational proximity. Each Earth wobble takes about 26,000 years to complete. It all means that the Sun and Moon do not now move quite as far to south and north at their limiting positions as they did in the prehistoric past.

Did people know all this thousands of years ago? That the Moon is on an 18–19 year maximum-minimum-maximum declination cycle? I believe this *was* known in ancient times. Tally-marked rocks, stones and bones have been found that archaeologists think indicate years marked off in groups of nine.

The sketch on the following page is a bone-handled tool found by Jean de Heinzelin at Ishango near Lake Edward in Africa (the present-day border of Uganda and Zaire). The right-hand end would have originally been part of something larger. This is dated at 9000 BC.

9 19

19 17

A much older bone from the Dordogne Valley of western France, dated at 30,000 BC, shows deep slash marks along the top edge, totalling 18 or 19, and what look like Moon marks are etched onto the left. In the photograph we cannot see what is on the other side in terms of 'moons', but clearly there are nine in a small group in the centre.

Are the circles moons? Below is a clearer view of marks on one of the bones found at the same site.

Linguistics may help here. The word 'new' may have originally meant 'nine' in ancient Egypt. Nine is half of 18. The word 'newn' was used to indicate both the rising of the Sun in the east and the first appearance of the new Moon. At the nine-year mark we get the Moon's minimum declination. Was the new Moon originally known as the 'nine Moon'?

Then there is the word 'climate'. The Greek word was *klima*, meaning slope of the heavens. Related words today are *climb* and *climax.* Of the Moon?

Where are we at now? When I was writing the first draft of this book (14 June 1999) the Moon had just reached the 20° 12' declination angle north and south of the equator each month. The perigees were in the northern hemisphere. The Moon was on the way up to the mid-point of the 18.6-year cycle, which it reaches on 1 August 2001. The most recent low point, 18°, was on 16 March 1997, and the next

maximum declination point, 28° 45', will be reached on 22 March 2006.

There are other cycles of the Earth that cause changes in the whole picture, because Earth's cycles also affect what the Moon does. One of these is the angle of precession, the 42,000-year oscillation in which Earth's tilt varies from side to side 21.4°–24.9°, much like a spinning top. At the moment we are 23.5° and increasing our tilt, which means that our seasons will get more extreme in a few thousand years.

There is also the polar wobble, in which the poles move around in a 22-year cycle, like a top when it starts slowing down. Also caused by the Moon's gravitational pull, this creates shifts in the position of magnetic north.

There are also cycles within cycles, like the monthly variation between the minimum declinations (18°) and the mid-points (23.5°), which sees always the same progression of 49 months, 50, 53, 54 and then 49 again; making a grander cycle of 4 x 18 years, or 72 years.

summary

The Moon moves in four main ways at once:
1. The phase cycle, which everyone can see (new Moon – Full Moon).
2. The perigee cycle, which can be noted with the aid of some measuring device or an official almanac.
3. The monthly declination cycle, which can be observed if you watch at the very time the Moon rises each day and record its position along the eastern horizon.
4. The maximum–minimum declination cycle, which cannot be seen, in which the Moon behaves like a roller coaster over 18.6 years.

What does all this mean for our weather?

what causes weather?

W herever the Moon happens to be around the globe, it affects the weather there. Also relevant is the time in its monthly cycle and its closeness (perigee). Most bad weather occurs in the second half of the Moon's phase – that is, between Full Moon and new Moon. Tornadoes occur before the Moon rises or after it has set – that is, when it is absent from the sky, which means at night during new Moon or day during Full Moon or Last Quarter. The same applies to hailstorms and cloudbursts.

Whirlwinds and waterspouts also occur at this time, but need heat ascending and so occur more in the summer months or in equatorial conditions.

At apogee (Moon farthest from Earth) the atmospheric tide is not as high on the Moon's side, so therefore not as low on the opposite side either. As the atmospheric effect is the one on the opposite side to where the Moon is, there tends to be fairer weather at apogee when the Moon is not in the sky.

Electrical storms are also phase-related, the most likely time being during the Last Quarter if (for the northern hemisphere) the Moon is at its southern monthly declination point. The converse applies in the southern hemisphere, when it is at its northern monthly declination

point. If lightning happens to be at night, it is more likely to occur around new Moon or first quarter.

When the new Moon is over the northern hemisphere and going south towards the equator, and conversely when the Full Moon is over the southern hemisphere and going north towards the equator, cyclones are generally absent in both hemispheres.

According to some alternative forecasting systems, the positions of the planets do have a bearing on the weather. One would be unwise to dismiss any possibility that seemed scientifically sound. Some environmentalists put much faith in the plotting and record-comparing of solar flare disturbances. Some systems involve just watching for sunspot activity, which appears to be on an 11-year cycle. But as the Moon is the closest to us, it is hard to overlook the fact that lunar gravitational attraction has by far the strongest potential to change things here on Earth.

Perhaps the Moon's role is that of a great shield. The solar wind from the Sun affects Earth with its electromagnetism and the Moon in new Moon shields Earth from that ionic onslaught. Hence new Moon is the right time for germination of young plants because they don't need to be hassled by a lot of charged particles running around. Last Quarter Moon is the main thunderstorm period, because not only is this solar shielding at its weakest, but also the Moon is pulling that same solar wind towards itself across the Earth's surface. Consequently the atmosphere becomes full of charged particles and the charges on the water droplets get polarised which results in precipitation. The total electromagnetism from the astro-belt is altered constantly by the shielding of the Moon. The Moon probably carries or reflects all planetary influences as a pure function of shielding. Therefore at any one time it must be causing a different collated picture of planetary 'influence'. It remains for someone else to study electro-winds from the planets and their subsequent ionisation coefficients by plotting the fluctuations in electrical charge on the atmosphere against each planet's changing proximity to Earth.

It has been suggested, for example, that the alignment of Saturn

(which orbits the Sun every 29.5 years) and Jupiter (which orbits every 11.9 years), when together on the opposite side of Earth to the Sun, correlates with widespread cyclonic weather on Earth. It might be that these two planets at that time are having the same effect that a Full Moon does on us. One could imagine that their combined gravitation could be pulling increased electrical activity from the Sun towards themselves, bringing it across Earth on the way.

Those who do think there is an influence by Saturn and Jupiter certainly must accept the Moon's role then, for the Moon is so much closer. At least planetary-influence thinkers are a step ahead of metservices, who seem unwilling to consider any other possibilities. (Also, wherever the Moon was at any given time, would still affect *this* process through interception or absence.)

The results arrived at by the planet theorists may still have been lunar-based. The average sunspot activity cycle of 11 years coincides with the orbit of Jupiter, and is caused by the proximity of Jupiter to the Sun. Jupiter is almost 318 times the size of Earth (if Earth were a peppercorn, Jupiter would be a grapefruit). Saturn is about 95 times as large as Earth.

Given these sizes, it is further likely that planets have an effect on each other and a *combined* effect on the Sun. In their half-orbits, Jupiter and Saturn are alternately together on the same side of the Sun, and then on either side at 180° to each other, with the Sun in the middle of them. This condition could be the catalyst to commence the sunspot cycle.

The famous Australian forecaster Inigo Jones employed this for many years in his long-range forecasting system. Jupiter and Saturn, he said, shielded the Sun from the magnetic field through which the solar system moves. At the time of this shielding, sunspots were absent from the Sun and this was a time for droughts in Australia. In between are times of sunspots, storms and floods. Based on this, droughts were forecast for the summer of 1995–96 and 1998–99 way back in 1949.

So far this has proven correct for the Crohamhurst Observatory he founded, and his successor Lennox Walker. The next big drought was

forecast for 2001–02, with dry summer, autumn *and* winter, followed by a dry spell in 2004–05 and a moderate drought in 2007–08.

The same results could have been forecast from lunar records. The combination of average sunspot-cycle periodicity and the cycle of Jupiter is about 35 years. The Moon's cycle of 29 days and the sunspots' rotation of between 24 and 28 days can be confused together. Without wishing to cast aspersions on the clearly successful work done by the Crohamhurst Observatory, it is worth pointing out that the sunspot effect, which uses records of similar rotation periods, could be shown to if not actually *be* Moon cycles all along, at least be paralleling them, and therefore leaving some questions unanswered.

El Niño

El Niño is a *regular* eastward migration of warm water from the tropical western Pacific Ocean. Because it was first noticed in modern times by Peruvian and Ecuadorean fishers, it has an Hispanic name.

Rather than being a recent phenomenon, samples from a lake high in the Andes have shown El Niño has been playing havoc with the world's weather for at least 15,000 years. A team led by Don Rodbell, from New York's Union College, digging in the Andes in 1999 found a continuous geological record and evidence that ancient civilisations 5000 and 8000 years ago planned for and used the El Niño rains to boost crop production.

Ice-core records from the Andes in Peru also suggest these climate fluctuations have been part of Earth's weather cycle for thousands of years. Some scientists speculate the topsy-turvy weather patterns began when glaciers stopped receding and sea levels stabilised some 5000 years ago. They have also identified El Niño signatures hundreds of thousands of years old in coral growth rates. From evidence found in coral reefs, tree rings and polar ice cores, scientists have now traced El Niños back through five millennia.

In the 1500s fishermen in Peru noticed that unusually warm coastal currents reduced their anchovy landings. At the same time, local

farmers noticed that the warming coincided with increased rainfall. Wondrous gardens sprang from barren arid regions, and the years were called *años de abundancia* (years of abundance). In other regions, torrential rains brought ruin. Because the warming often peaked around Christmas, the current was named '*El Niño*' (the Christ child).

Eighteenth-century European sailors recorded other bizarre events in their logbooks. The coastal waters were stained crimson with El Niño. Their ships' hulls were rotting in oxygen-depleted waters that were suddenly home to exotic sea snakes, alligators and sharks.

In a normal year, the trade winds blow from South America to Asia, pushing warm water to the far reaches of the western equatorial Pacific. During an El Niño, this pool of warm water sloshes across the Pacific to Peru as the normal winds weaken. The warmer-than-normal water adds heat and moisture to the air above it, creating thunderclouds and an atypical storm track with far-reaching effects.

High temperatures and flooding in parts of the northern hemisphere in recent times add up to El Niño weather patterns. During 1974–75 sea currents ceased to flow strongly from the Southern Ocean, causing fish to either die or migrate to more fruitful areas to feed. Because the usually nutritious current ceased to provide sufficient food at that time, the fish departed, the sea birds died as there were insufficient fish left to feed them, and fishermen went bankrupt.

In 1982 a monster-sized El Niño rolled across the Pacific with wildly unexpected consequences. It was the largest, most intense El Niño in modern times. Farmers in Peru were up to their eyeballs in rain. Fires scorched Borneo. Droughts hit Australia. An estimated 2000 people died. All told, the damage estimates ranged from $8 billion to $13 billion.

Between 1983 and 1992, and probably at other El Niño times, the east coast of the North Island, New Zealand, was subjected to a 'bloom' on the sea floor, preventing bottom-feeding fish from receiving sufficient food and so dying because there was insufficient tidal or current movement to clear the 'bloom' away.

El Niño is correlated with droughts in Australia, Indonesia, Zimbabwe

and Ethiopia, stronger hurricanes in the eastern Pacific and weaker ones in the Atlantic. Scientists have had lots to do since 1997 was identified as the beginning of an El Niño cycle.

But meteorologists worldwide, at a loss to explain every unusual weather pattern, seem to offer the words 'El Niño' first. You hear it said at the end of almost every forecast: 'It's the El Niño pattern again,' or, 'Typical El Niño weather at this time of the year.' There's more.

La **Niña**

After the summer of 1988–89 we were introduced to a new phrase: 'La Niña'. This was said to be the *positive* phase of the southern oscillation, the opposite of El Niño – in fact, El Niño's cooler sister. La Niña was immediately stated to be the reason for the drought in the South Island of New Zealand. It also happened to be the beginning of decline of the 28° declination of the Moon. The previous dry spells had been in 1969, 1950, 1932 and 1914 – all years of the Moon in 28° declination. Now we were told that immediately after any El Niño effect there comes a La Niña. If it is raining we could be in La Niña. If it's not, we are still in El Niño. (That's like the joke about the hills: If you can see them clearly, it's going to rain; and if you can't, it *is* raining.) We now learn an El Niño winter is usually followed by a La Niña one. Where there was flooding there is now drought; where winter weather was abnormally mild, now it is abnormally harsh. La Niñas have followed so-called El Niños three times in the past 15 years – after 1982–83, 1986–87 and 1995.

On 29 January 1999 I noted the first of three comments published in the *New Zealand Herald*. A spokesman for the National Institute of Water and Atmospheric Research said:

> We are looking at significant problems in the decades ahead and incredibly depressing problems in the next century or two.

And in an article on 20 February 1999:

> The La Niña pattern will continue through autumn… over the next three months… there is only a slight chance of above-average rain.

They didn't know that rain was imminent. Ten days later, in the same newspaper:

> There are signs that the La Niña weather system may be on its way out.

We had previously witnessed a university ecologist making front-page news saying orchardists (in our temperate climate) had better start growing tropical fruits. It seems that one moment the La Niña pattern will persist for the next 50 years, and the next moment, as soon as it rains once, 'Well, I guess it's gone now.'

A scientific statement, especially if it's presented as a news release, should be backed up with reason. Drought follows rain eventually. If El Niño brought storms, what follows must sooner or later be fine weather. But that is not science, it is plain old inevitability.

what causes **El Niño**?

El Niño is as much an atmospheric event as an oceanic one. The winds and waters communicate with each other halfway around the world, influenced together by the Moon. El Niño is what happens when the Moon's declination and the Earth's tilt at 23.5° coincide. In the table following you can see that the next El Niño will be near 2016. El Niño is merely the 18°, low-point in the 18.6 year maximum–minimum declination cycle.

This means that the Moon transports the warm tropical atmosphere into the temperate zones, thus increasing the average temperatures there. A warm band of water will appear, which will warm only the area between the tropics. The result will be very cold winters in areas

CYCLE STAGE	18 DEGREES MINIMUM	23.5 DEGREES	28 DEGREES MAXIMUM	23.5 DEGREES
NOMENCLATURE	El Niño	Mid-point	Greenhouse Effect Global Warming	Mid-point
EFFECTS	Extremes: heat waves in summer, record snowfalls in winter, floods, droughts, cyclones, more gales, blizzards	Average conditions	Long droughts	Return to average conditions
YEARS	1885 1904 1922 1941 1959 1978 1997	1889 1908 1927 1945 1964 1982 2001	1894 1913 1932 1950 1969 1987 2006	1899 1918 1937 1955 1974 1992 2011

of the upper northern hemisphere and southern areas such as the South Island of New Zealand. It will also mean heat waves in those areas in the summertime, because there is not as much atmospheric insulation from the heat of the Sun (as the atmosphere is localised by the Moon's transit to the area between the tropics).

During the next nine years this 5° high part of the inclination (referred to as the north inclination) above the plane of the Earth's orbit will move 20° a year around the orbit (20 x 9 = 180°). This translates, by the declination moving downwards by about a degree a year, to 18° which is 5° inside the tropics.

This was a period the world was in recently, from 1995 to 1998. Less warm tropical air was moved by the Moon north and south of the equator each month into the temperate zones, bringing with it below-average temperatures in winters at extreme latitudes.

The 1974 and 1992 El Niños had the same components; a 5° northern inclination to the sun, and a 5° inclination below that plane at the spring equinox of the southern hemisphere. The Moon, as it were, hinges upwards at the Tropic of Capricorn when moving northwards, and downwards from the Tropic of Cancer when moving south.

During 1964, 1982 and 2000–01, the slope is in the northern hemisphere at its autumn equinox. The overall effect is that the 1974 and 1992 periods affected the northern hemisphere more than the southern hemisphere. The 1964 and 1982–83 years affected the southern hemisphere more than the northern hemisphere and 2001 will also affect the southern hemisphere more. As the Moon's orbit is carried over 18.6 years, there is a carry-over lag towards 19 years between El Niño periods.

what **weather** are we into now?

The temperatures in the Pacific Ocean are, at time of writing (year 2000) still above the average because the Moon's restricted movement is at 22° north and south of the equator each month; still 4° inside the tropics and holding the Sun's heat within that tropical belt. The years when the Moon was at the 28° declination this century and offering higher temperatures and droughts for a year or two on each side were 1914, 1932, 1950, 1968, 1986 and the next will be near 2006. The cool years were those near 1905, 1923, 1941, 1959, 1978, 1997 and will be again about the year 2014. We are coming up to the midpoint, 2001–2. There will be cold winters and hot summers in the far south of the world (e.g. South Island of New Zealand) and the far north (US, Canada and UK) up until this time. After 2004 the winters will be wetter and warmer, and the summers more mild.

19-YEAR CYCLE	18° MINIMUM	23.5°	28° MAXIMUM	23.5°
Names	El Niño	Midpoint	'Greenhouse Effect' 'global warming'	Midpoint
Effects	Droughts, storms, floods, cyclones, gales, more snow, blizzards, heat waves	Relatively more average conditions	Drought	Relatively more average conditions
Years	1885 1904 1922 1941 1959 1978 1997	1889 1908 1927 1945 1964 1982 2001	1894 1913 1932 1950 1969 1987 2006	1899 1918 1937 1955 1974 1992 2011

Harry Alcock collected local rainfall figures based on the maximum declination of 28° against the minimum of 18° over a three-year period while the Moon was at that declination and covering three periods of the 18.6-year cycle. The results are illuminating.

THE 28° YEARS	1949	3059 mm (120 inches)
	1968	3299 mm (130 inches)
	1986	3029 mm (119 inches)
	Total	9387 mm (369 inches)

THE 18° YEARS	1940	3381 mm (133 inches)
	1959	3592 mm (141 inches)
	1977	3496 mm (138 inches)
	Total	10,469 mm (412 inches)

The *difference* between the 28° and 18° rainfall figures is consistent, and in total 1082 mm (43 inches). The changing declination of the Moon from the 28° down to 18° and back again to 28° north and south of the equator has the depressions and anticyclones drifting eastwards at *differing* latitudes. Depressions, being 'further down country' already, would drift *farther* south-eastwards over the southern hemisphere when the Moon was at its minimum. And this did occur frequently during the winter of 1997.

The declinations control the direction of depressions. As the declination moves either north or south, so the depressions will cross the country with those changed latitudes. The same changing latitudes will take place with anticyclones. In 1999, in New Zealand, anticyclones were predominantly about the south of the South Island, with winds over the North Island frequently from an easterly quarter. With a 28° declination the anticyclones will seldom cross New Zealand to the south. Anticyclones will follow the Moon north-east when the Moon is moving from the southern hemisphere northwards and south-east when moving southwards. The east drift as a component of the south-east or north-east drift, follows the Moon's orbit, which is eastwards around the Earth.

Tidal heights are also affected by the changing declination of the Moon between the 18–28° north and south of the equator each month over the nine-year period. Erosion therefore probably has a cycle, which may explain the disappearance of some sand banks and low-lying areas, that hitherto have been attributed to rising sea levels.

It follows that the declination shifts the location of cyclones. As the Moon changes its declination angle 1° a year, the latitudes at which cyclones or depressions occur change by the same rate. That is why cyclones vary from year to year. The only time comparisons can be made between one year and the next is when the Moon is at maximum or minimum declination of 18° or 28°, because for about three years around these points the Moon's declination is relatively stationary. These stationary years have been 1995–1999 (18°) and, coming up, 2004–2008 (28°)

Anticyclone direction alone can demonstrate the influence of the Moon. As the Moon travels from east to west, it tends to drag the atmosphere with it. The Moon exerts its pull along its path that is between the tropics. That means a band of atmosphere around the Earth's equator is pulled eastward. But the Earth is rotating west to east faster underneath it. Lighter and more numerous water-laden-free gases move the easiest, meaning anticyclones closest to the equatorial belt will be the most pulled east. Consequently, the faster rotation of the Earth will cause a 'lag' to occur at the equator, the point of greatest gravitational pull. That means the southern edge of the northern anticyclone and the northern edge of the southern anticyclone are moving westwards, away from the direction of the Moon's pull. Gaps occurring between fast anticyclonic currents cause surging eddies, much as can be seen when two opposing ocean tides come together at the end of a long peninsula, for instance at Cape Reinga in New Zealand. These vacuums between anticyclones can quickly become areas of low pressure where inclement weather can develop, which is why hurricanes often originate in mid-Pacific latitudes around the areas of New Guinea and Fiji.

the barometer

In 1638 Galileo noticed that a suction pump used to pull water from a well could not raise water more than 34 feet. His pupil, Torricelli, realised that this was due to the weight of the atmosphere and confirmed his theory with an experiment. Knowing that mercury is 14 times heavier than water, he realised that if 34 feet of water was held up by the atmosphere in a column (such as a well, or a tube), then an amount of mercury one-fourteenth that of water might also be held up.

So he took a tube three feet long and filled it with mercury, sealed the end momentarily with his finger, inverted the tube and immersed the end in a bowl of mercury. (The health hazards of this were not then known.) The level of mercury in the tube was about 30 inches. The empty space at the top was a vacuum. Watching it and recording over several days, Torricelli discovered that there were variations in the height. Without realising the full implications, he had demonstrated the existence of air pressure and invented the barometer and altimeter.

The French scientist Blaise Pascal repeated Torricelli's experiment and realised that any air closer to Earth would be compressed by the weight of air immediately above it, and therefore that air high on mountain tops would be of less pressure. He proceeded to demonstrate

this, climbing to the summit of Puy-de-Dôme and returning to the sea-level town of Clermont-Ferrand all in one day, with measuring equipment and observers on the ground. From this he gave the world the altimeter, measured in kilopascals (kPa), hence still bearing his name.

proof of atmospheric tides?

Pascal conducted his experiment on 22 September 1648. He had planned to do it three days before on the 19th but had to wait for the unsettled weather (typical of a perigee Moon!) to clear. Indeed, the records reveal that 18 September was the day of the new Moon and perigee combined. The 22nd would have been a day Moon, close to the Earth. The atmosphere would have been higher by day and narrower by night, accentuated by the perigee.

Pascal could not have known that the barometer is silent testimony to the existence of atmospheric tides. It measures the weight of atmosphere pressing down on a surface, which is atmospheric pressure but unfortunately not atmospheric volume, i.e. height.

	BAROMETER STEADY	BAROMETER DROPS	BAROMETER RISES
Moon rising (volume of air increasing)	If temperature rises	If temperature is steady	
Moon setting (volume of air decreasing)	If temperature drops		If temperature is steady

For readers who are confused, cast your mind back to high-school physics, and Boyle's law, which states that volume and pressure are inversely proportional to temperature. A glance at the table may clarify matters. When the volume of a gas decreases, as is the case on your side when the Moon is on the far side of the Earth, pressure varies with temperature. That means that if it goes cold the barometer will stay the

same – as long as the volume keeps decreasing! But if it gets warmer the barometer will rise, if the volume of the gas is still depleting.

And if the volume of the atmosphere overhead is increasing because the Moon is returning some of the atmosphere from the other side, as it would do four or five afternoons after the new Moon (on the day of Pascal's experiment the Moon was not in the sky until mid-afternoon), then as the temperature increases, the barometric pressure will remain the same. By noting the changing temperature, using another method of measurement (a thermometer), and adding that to the fact that the barometer had stayed the same, Pascal might easily have deduced that the volume of the atmosphere had increased! If he had figured out the Moon's effect on the atmosphere and calculated in the phase times, he might have realised just what the atmosphere was really doing.

Consider the times. It was new Moon four days before, new Moon time 2am. Given that the Moon rises 50 minutes later each day, this puts moonrise at between 4pm and 6pm in France on that day. He spent time on the mount, then came down. Being September late afternoon, the temperature would have dropped slightly as the Moon was bringing the atmosphere back. The increased volume would have cancelled out the temperature drop and the barometer would have stayed steady. Which is exactly as reported.

It was all there: when Pascal returned from the mount, Father Chastin, his sea-level observer, reported that the quicksilver level had remained constant despite the weather being very unsettled, then clear and still, then rainy, foggy and finally windy!

If the new Moon is rising, the barometer stays steady if it gets warmer and drops if temperatures stay the same. If the new Moon is setting, the barometer stays steady if it gets colder and rises if temperatures stay the same.

This also explains heat waves. When the Moon is not in the sky, the atmosphere is depleted; and if there is a high-pressure system operating there is no atmosphere to keep the Sun's heat from increasing the ground temperature.

In fact, expecting a barometer to measure atmospheric thickness is

about as successful as expecting a thermometer in boiling water to read differently from one in boiling soup. In the same way, a weather balloon (which houses a barometer) if allowed to rise and fall with the atmosphere (buoyant like a ship or cork in the sea), gives no information out about its true height but tells instead only of the surrounding temperature.

Pascal also missed a previous opportunity by only two days. Had he gone up the mount four days beforehand, when he had originally planned to, and taken note of the Moon-tide day and night differences in pressure at that height (which would have entailed staying up on the mount), then compared them to those taken at sea level over the same period, he might have noted some pressure discrepancy changes over the course of a day that could be expressed as a function of height. This would have established the existence of the atmospheric tide effect and at the outset perhaps changed the course of modern meteorology.

The atmosphere can alter in height by several miles twice a day like the sea tide. Yet the barometer may not change, because it does not and cannot measure atmospheric height. Such an experiment has yet to be done. However, an alternative and, to my mind, excellent experiment has been done.

Harry Alcock told me of an experiment in which he fitted a filtered photographic exposure meter to a telescope aimed at the Sun. The meter was thus graduated for a reading range of 14.0 to 14.7. The telescope had an elevation angle calibration fitted, and readings were taken throughout the day so Sun angles could be catered for. Brightness values were recorded on every cloud-free day. Later, the experiment was repeated using a Cushing solar energy meter, yielding the same results. Why brightness? Because the thinner the atmosphere, the brighter will be the Sun, there being less interference to the passage of the Sun's rays through the atmospheric layers.

The readings under similar conditions through a succession of Moon phases showed brightness could vary by up to 25 per cent. Taking the accepted total atmospheric depth to be 60 miles, the difference in the height of the atmospheric bulge, then, could be up to 15 miles. Readings

always increased in intensity before rain – without fail the rain arriving the next day. Moreover, if the increased brightness was in the afternoon, then that was also an indication it would rain on the morrow. The readings would increase while the barometer stayed high if a front was approaching and if a clear day and high reading, the following day was nearly always cloudy.

Having said all that about barometers, the instrument can be useful when the Mercury is actually in change, but at the same time one should watch the thermometer. Then you can more safely predict some change in the weather. But when the needle stays constant the weather may change or stay the same. At any one time you can't, just by looking at the barometer *alone,* tell if the atmosphere is high or low.

how to best use
the **barometer**

A barometer is a tiny copy of the larger scene, as is a map of a landscape. Inside every instrument is a column of liquid (alcohol or Mercury). Air pressure on the surface pushes the surface level down and that amount is simply measured against a scale etched alongside. The assumption is that this little micro-picture reflects what is happening on a grander scale at that geographical point. On the bigger scale millibars are the units of pressure of the weight of all the air in a supposed narrow column going right up to the top of the atmosphere above any fixed land point.

Pressure, as we all know when we put our finger against the tabletop, is when something is pushed. Moon as a gravitational force cannot push anything. Gravitational force pulls, which is not the same thing. Measuring the pressure of the waves coming up the beach won't tell you if it is high or low tide. But volume of water at that point will. What we want to establish atmospherically speaking is volume. We want to know how much atmosphere is in a particular space, because more atmosphere means more protection against sun and cold.

Is there a way to use the barometer to 'read' weather changes? Yes, in

conjunction with a thermometer.

- If the barometer stays the same but the temperature drops, there's a chance of rain.
- If the barometer stays the same but the thermometer rises, expect a clearing.
- If the barometer goes up but the thermometer stays the same, rain could ensue again.
- If the barometer rises or falls while the thermometer plunges, a thunderstorm could be close by.
- Barometer falling with thermometer rising: heavy rain.
- When both rise, either the wind is about to change or the weather is to improve.
- When both fall, weather is deteriorating quickly.

So if the barometer is constant, it means rain or clearing; if it drops, rain, frost, or thaw and if it rises wind change, gale, rain, frost or clearing.

- The Mercury level seldom falls for snow.
- A first rise after a low, or a rapid rise, can indicate unsettled weather.

If you want to buy a barometer, choose the one with as many bellows as you can afford – the more bellows, the more accurate. The best of all though, is a barograph.

The average rate of fall of the barometer when signalling a warm front (which can cause a depression, as does a cold front) is 2.5 mb/h. For the first five hours the rate will be low (1 mb/h), but over the next five to ten hours the rate of fall increases. In about four hours the rate may be 3 mb/h – a gale warning!

Barometer Rises		Barometer Stays Same		Barometer Falls	
Temp drops	Chance of rain	Temp drops	Chance of rain	Temp drops	Quick deterioration
Temp rises	Improvement	Temp rises	Clearing	Temp rises	Heavy rain
Temp stays same	Chance of rain				

Robert Fitzroy, captain of the *Beagle,* on which Charles Darwin sailed around the world, formulated 'forecasting remarks' that became popular and were inscribed on barometers. The practice continues on instruments to this day.

barometric changes

- A fall of half a tenth of an inch or more in half an hour is a sign of storm.
- A fall when the thermometer is low indicates snow or rain.
- A fall with a rising thermometer indicates wind and rain from the southward.
- Sharp rise after low foretells stronger blow.
- Sinks lowest of all for the great winds, not necessarily with rain.
- Greatest heights are for easterly or northeasterly winds.
- In calm frosty weather, the mercury stands uncommonly high.
- After very great storms, it rises very fast.
- The more northerly places have greater alterations.
- In very hot weather, the falling indicates thunder.
- In winter, the rising presages frost, and in frosty weather, but if the mercury falls three or four divisions, there will be a thaw.
- If a continued frost and the mercury rises, there will be snow.
- Unsettled motion of mercury, uncertain changeable weather.
- Sudden fall in spring, winter or autumn means high winds and storms, but in summer heavy showers and thunder.
- When there has been no storm before or after the vernal equinox (21 March), the ensuing summer is dry, five times in six.
- Steady rise shows that fine weather may be expected, but in winter – frost.

This list of rules is inscribed on a typical northern hemisphere instrument. In the main they are correct for that location.

predicting

1. plot declinations
for the month

The Moon, you will recall, moves around the Earth once a month on or about the Earth's plane of orbit around the Sun. It strays 1° a year from this plane, never going above or below 5°, making for an 18.6-year cycle in all. But within the month, it spends 14 days in one hemisphere and 14 days in the other, oscillating around the Earth's elliptic.

When it is uppermost it is at the northern declination point, and travelling parallel to the Earth for three or four days. The weather will be slow moving. Winds and anticyclones will be dragged along latitude lines.

Then the Moon plunges downward towards the southern declination point. Dragged by the Moon as it crosses the equator (either going northwards towards its northern declination point, or southwards towards the southern point), weather patterns at this time are often called 'fast-moving' weather systems. Winds at this time will generally be northerly (from NE or NW) or southerly (from SE or SW).

How do you find out when the declinations occur? In the Append-
ices the declinations are listed for 2000 and 2001. By keeping daily
records of moonrise angles, you will be able to see the pattern emerge.
You can get these angles from your local newspaper. Another way is
to obtain a publication produced every ten years called the *American
Ephemeris*.

2. **get in tune** with the perigees

The perigees in the years 2000 and 2001 are listed in the Appendices.
Thereafter, if you don't want to keep referring to a measuring stick
held up to the Moon, information on when to expect its next perigee
can be found in nautical almanacs published by the Coastguard, and
in many Moon calendars. The weather will nearly always turn for the
worse at perigee time, dishing up winds, high swells, high tides,
stronger winds and possible gales.

3. **plot and compare past cycles**

The total new/Full Moon cycle is (at 18.6 years) roughly 19 years, as
can be seen in the following two tables, in which full Moons 19 years
apart occurred or will occur on nearly the same day. The implication
is clear: weather can be predicted by looking back; the weather condi-
tions in the future will be the same as in the past if the Moon is again
in the same place in the sky.

This does not mean one should look only at weather maps 19 years
ago. Perigees must be taken into account, and monthly declinations
must match. Also, moonrise and moonset times must also
approximately concur, because they have a bearing on atmospheric
tide. But when you get those right – bingo, you can predict the weather.

full moons

	JAN	FEB	MAR	APR	MAY	JUN	JUL	AUG	SEP	OCT	NOV	DEC
1981	20	19	21	19	19	18	16	14	14	14	12	11
1982	10	8	10	8	8	7	6	5	4	3	2	1
1983	29	27	29	27	27	25	25	24	22	22	21	20
1984	19	17	17	16	15	14	13	12	10	10	9	8
1985	7	6	7	5	5	3	2	30	29	29	28	27
1986	26	25	26	25	24	22	21	20	18	18	16	16
1987	15	14	16	14	14	12	11	9	8	7	6	5
1988	4	3	4	2	31	30	29	27	26	25	24	23
1989	22	21	22	21	21	19	19	17	15	15	13	13
1990	11	10	11	10	10	8	8	7	5	4	3	2
1991	1		1	29	28	27	27	25	24	23	22	21
1992	20	18	19	17	17	15	15	13	12	12	10	10
1993	9	7	8	7	6	5	4	2	1	1	29	29
1994	28	26	27	26	25	23	23	21	20	20	18	18
1995	17	16	17	16	15	13	12	11	9	9	7	7
1996	6	5	5	4	3	2	1	29	27	27	25	25
1997	24	22	24	23	22	21	20	18	17	16	15	14
1998	13	11	13	12	12	10	10	8	6	6	4	4
1999	2	1	2	1	30	29	28	27	25	25	23	23
2000	21	20	20	19	18	17	17	15	14	13	12	11

	JAN	FEB	MAR	APR	MAY	JUN	JUL	AUG	SEP	OCT	NOV	DEC
2000	21	20	20	19	18	17	17	15	14	13	12	11
2001	10	8	10	8	8	6	6	4	3	3	1	1
2002	29	27	29	27	26	25	24	23	22	21	20	20
2003	18	17	18	17	16	14	14	12	11	10	9	9
2004	8	6	7	5	5	3	2	30	29	28	27	27
2005	25	24	26	24	24	22	21	20	18	18	16	16
2006	14	14	15	14	13	12	11	9	8	7	6	5
2007	4	4	4	3	2	1	1	28	27	26	25	24
2008	23	23	22	20	20	19	18	17	15	15	13	13
2009	11	10	11	10	9	8	7	6	5	4	3	2
2010	30		1	29	28	26	26	25	23	23	22	21
2011	20	18	20	18	17	16	15	14	12	12	11	11
2012	9	8	8	7	6	4	4	2	1	30	30	28
2013	27	26	27	26	25	23	23	21	19	19	18	17
2014	16	15	17	15	15	13	12	11	9	8	7	6
2015	5	4	6	4	4	3	2	30	28	27	26	25
2016	24	23	23	22	22	20	20	18	17	16	15	14
2017	12	11	13	11	11	10	9	8	6	6	4	4
2018	2	1	2	1	30	28	28	26	25	25	23	23
2019	21	20	21	19	19	17	17	16	14	14	13	12

other **forecasting** systems

Many systems have been proposed, and most will work in their own way once the operator gets 'in tune' with his/her system. For example, the Herschel Chart is a forecasting device collated by farmers in Europe nearly 400 years ago, and later named after an astronomer-royal in England, Sir William Herschel. He devised this particular methodology to predict the weather long range so that he could arrange for his observing sessions with the telescopes.

The Herschel Chart takes the time of change of phase of the Moon and converts it to a prediction of the weather over the next few days after the Moon changes phase. The exact time of change of phase of the Moon is determined by looking up charts 40 to 50 years in advance.

Subsequent to the Herschel Chart, Richard Holle, of Concordia, Kansas, suggested that one can plot the following cycles from the past to predict an average reading for rainfall, sunshine, wind speed, humidity, etc. So for 1 January 1995 the comparable dates would be:

18 January 1939
31 December 1956
15 December 1974

The reader can extrapolate other related dates and use Richard's system for *any* date, if the trouble is taken to do so.

In America, Benjamin Franklin wrote and published his own *Poor Richard's Almanac*, predicting the weather for 25 years from 1732. At that time it was usual practice for people to carry pocket almanacs that included daily weather predictions – much as one would carry a pocket diary today – and Franklin's average annual sale was about 10,000 copies.

In France, Jean Baptiste Lamarck issued long-range weather predictions based on lunar data in his *Annuaire Meteorologique* from 1800 to 1811. And in Germany, Rudolf Falb (1833–1903) became known as 'the lunar prophet'.

historical **evidence** for cycles

From the *Annals of Loch Ce*, we know that the summers of 1252 and 1253 were so dry that people crossed the River Shannon in Ireland without getting their feet wet. This matches the conditions of 1975 and 1976, the worst drought in England and Wales since rainfall records began. The difference is 722 years, almost exactly 38 19-year cycles.

In between (nearly 22 x 19-year cycles later) was the Great Fire of London in 1666, which was a period so dry that the River Thames was just a trickle. We can compare 1252 to 1986, when the 'Greenhouse Effect' was first named. The timespan is 734 years, about 40 cycles.

In the following table dates are shown in pairs to reveal month-period samples. For example, in March 1893 through to May of the same year, 2.8 inches of rain fell; this is equivalent to the rainfall in February–April 1929. The rain in inches matches the two time intervals, which are a multiple of Moon cycles apart in years.

In New Zealand a severe drought occurred in Otago, in the South Island, in 1982. It was repeated in 1999, almost one cycle later. Yet each time a drought occurs it is described by locals as 'the worst in living memory'. Rather than any momentous shift in the world's climate, it is far more likely to be an indication of the fallibility of living memory.

There is no doubt that looking back at old records is helpful. I use several cycles (or rather recycles) and average them out. Some alternative forecasters latch onto just one system that works for them – they adjust it in their mind slowly over time with careful observation, once they get a basic framework. One often encounters farmers, surveyors, mountaineers, fishermen and foresters who are legendary forecasters in their own environments. They swear by what they have come to know and rely on.

the worst droughts in England and Wales between 1820 and 1976

Year	Starting Month	Period	Rain (Inches)	Year Difference	Approx. no. of Moon Cycles
1893	March–May	3 months	2.8	(1929–1893) = 36	
1929	Feb–April	3 months	2.8		2
1921	Feb–Aug	6 months	7.0	(1976–1921) = 55	
1976	March–Sep	6 months	8.1		3
1854	Feb–Feb	12 months	24.3	(1888–1854) = 34	
1888	Feb–Feb	12 months	24.5		2
1921	Aug–next Dec	16 months	34.6	(1975–1921) = 54	
1975	May–next Sep	16 months	29.8		3
1853	Dec–next June	18 months	36.7	(1887–1853) = 54	
1887	June–next Dec	18 months	39.2		3
1857	Dec–next June	18 months	40.6	(1874–1857) = 17	
1874	Feb–next Aug	18 months	40.5		1
1853	Oct–Oct	24 months	56.6	(1887–1853) = 34	
1887	Feb–Feb	24 months	58.7		2

4. check out the **wind**

According to 'Buys Ballot's Law', dating back to 1857, *when the wind is blowing on your back*, the low pressure (bad weather coming) is

- always *on the left hand* in the northern hemisphere, and
- always *on the right hand* in the southern hemisphere.

This is fairly accurate and refers to how the wind in the northern hemisphere blows anticlockwise around a centre of low pressure and clockwise around a centre of high pressure.

predicting

5. look at **clouds**

The coldest clouds are found at high altitudes while warmer clouds are found closer to the Earth's surface.

There are three basic cloud types. The first is *cumulus* cloud (Latin for 'pile') which looks like cotton wool or ice cream. It is like steam, water vapour that sits mainly at an altitude of 600 m (2000 feet) – the height at which rising warm air condenses out in the formation of water vapour. Cumuli form mainly when the Moon is absent from the sky, in the morning during first quarter, at lunchtime during Full Moon and in the afternoon during Last Quarter. Generally, if seen in the morning, cumulus is more likely to spell rain. If it develops in the afternoon it will probably clear by evening.

The second type is *cirrus* (Latin for 'curl') and its variations. This sits far higher, anything up to 20 km (12 miles) up, and is composed of ice. Cirrus can look like candyfloss, or mares' tails and can become cirro-cumulus or 'mackerel sky', which resembles closely packed ribs in rows. If cirrus is in the daytime it is mostly when the Moon is in the sky, often during new Moon.

The third is *stratus* (Latin for 'layer') which is undefined, covering the sky and with no edges. They are misty and blurred. From their first appearance expect a cloud-filled sky in 24 hours but not rain.

Cumulus mainly indicates settled weather, cirrus means a depression is coming. When cirrus is very sparse and doesn't cover the sky it can mean settled weather, so it can pay to watch to see if it increases or dissipates. It is a sign of bad weather developing when cirrus starts to spread from one horizon to the other, above the bunchy cumulus. From the first sign of cirrus spreading, expect the weather to worsen in 36 hours. Cirrus heralds the beginning of a depression and also the end of one. Slow formation over the whole sky indicates bad weather for a long duration, quick formation means a storm that will last only a day. If it has been stormy and you see cirrus clouds you can safely say that the storm has finished. Fine weather will generally occur within 24 hours if the wind doesn't change.

Cloud Type	Description	Level	Prediction
Cirrus	Mares' tails	9 km (5.6 miles)	Often first sign of change
Cirro-stratus	Spread out candyfloss	8 km (5 miles)	Unsettled, sure sign of rain
Cirro-cumulus cloud	Mackerel sky	7 km (4.3 miles)	The '24-hour warning'
Alto-cumulus	Tufts, resembling sheep	6 km (3.7 miles)	Sign of coming thunder
Alto-stratus	Like grey ground glass	5 km (3.1 miles)	Carries rain and snow
Cumulo-nimbus	Like anvils or towers	4 km (2.5 miles)	Heavy rain, thunderstorms
Cumulus	Like ice cream	3 km (1.8 miles)	Forming in morning – will rain. In afternoon – will clear
Strato-cumulus	Like blurry, ripply pond	2 km (1.25 miles)	Door to a cold front
Nimbo-stratus	Big grey blotches	1 km (0.6 miles)	Light rain
Stratus	Like mist	0–1 km	Hill cloud, fog, drizzle

When you see clouds many-layered, in vertical halls and columns and clearly arranged simultaneously at different altitudes, this generally means unsettled weather is approaching.

Haloes and coronas around the Moon, often associated with cirrus, indicate the presence of middle- or high-level clouds which can mean cold fronts, advancing rain or storms. Hence the saying:

A circling ring of deep and murky red, soon from his cave the God of storms will rise.

Proverbs

Over many hundreds of years folklore has added to and at one time made up the bulk of forecasting. Included here are those sayings that have a lunar-scientific basis and so can be relied on to work almost anywhere.

- Rainbow at night, sailors' delight – rainbow in morning, sailors' warning.

(Refers to atmospheric tide around Full Moon time. A rainbow seen in the evening will be in the east, denoting rain going, whereas a rainbow seen in the morning will be in the west, indicating rain coming. A rainbow seen at noon means heavy rain is not far away.)

- The Full Moon eats clouds.

(Refers to the fact that the Moon above the horizon is more likely to yield good weather. The reason the Full Moon is so often seen is because the higher atmosphere allows less cold air in from space.)

- When dew is on the grass no rain will come to pass.

(Refers to clear cold nights of the Full Moon, Waning gibbous and third quarter)

- Rain before seven, shine before eleven.

(Refers to the first quarter Moon phase.)

- Frost on the shortest day – 22 December.

(Tides are greatest at solstices, in the month when the Moon is at its maximum distance from the equator, north or south, or, as astronomers and astrologers say, in the greatest northern or southern declination. The December northern declination will always be on a Full Moon. The frost will occur in the Full Moon time.)

- The weather turns with the tide.

(Refers to the atmospheric tide which is synchronised with the sea tide. There is also a friction effect of the air in contact with the sea surface, which changes direction at tide turn. If it was raining it may often stop when the tide changes; if it wasn't raining, it may start on the turn – provided that rain is about.)

signs in nature

1. Of worsening weather

(Animals seem unsettled)

Cows stop eating, lie down before rain or gather together in a corner.

Ditches smell dank and damp.

Sheep stay under trees.

Cats rub their ears. Chickens roost late.

Bees are excited and seek protection, returning to the hive before a storm.

Insects become more active, flying close to ground and water.

Spiders disappear.

Birds and bats fly lower. Birds appear excited, flock together, and fly this way and that.

Frogs croak more.

Scarlet pimpernel flowers close.

Pinecones close.

Seaweed becomes limp.

Early arrival of the waxwing in autumn indicates a harsh winter. (Europe)

Dolphins sporting in a calm sea prophesy wind from the quarter from which they came.

Ants hurry to and fro, carrying their eggs in circles when rain is about.

Seabirds fly into the interior.

Aquatic birds leave inland lakes.

Swamp birds nest further up valleys, to coincide with expected water levels when eggs hatch.

Cattle enter stalls late.

Roe deer and other game seem to lose their shyness and leave the woods.

Fish jump from water.

Earthworms come out of holes.

2. of better weather

(Animals seem industrious)

predicting

Swallows fly high in search of insects.
Spiders spin webs. Seaweed stiffens.
Bush birds stay longer in bush in summer with winter still far off.
Early-spring arrival of swallow and cuckoo. (Europe)
Dolphins splash in a billowy sea.
Cranes fly high in silence.

3. of weather change
(Animals seem annoyed)
Owl or morepork screech.
Sheep skip and sport.
Oxen sniff the air or paw the ground.
Many birds have special rain or weather calls.

4. of earthquakes
(Animals seem to panic and want to get out into the open)
Chickens shriek, won't go into coops.
Cats completely disappear, and mice and rats run around freely.
Wild cats wail.
Cattle kick up a commotion.
Dogs run in circles.
Birds call in the dark.
Caged birds flap wildly and call out.
Fish jump above the water surface.
Rabbits raise their ears, jump aimlessly and bump things.
Insects form swarms.

weather in **Britain**

British weather is typically a series of depressions.

WIND FROM	WEATHER
South and south-east	Fair, followed by cloud, then rain from west. Warm.
South-west	Overcast, cloud, drizzle, fog, warm.
West and north-west	Squalls, thunderstorms, hail, but then becoming fine. From Atlantic can bring brief snowfalls.
If anticyclone is over Scandinavia	Long fine spells (summer).
East and south-east	Dry and warm (prevents depressions from forming). Britain experiences spells of regular anticyclonic weather about the second week in September, early October and mid-November.

weather in **New Zealand**

Weather comes mainly from the west, south-west and north-west.

WIND FROM	WEATHER
South-east	Fair and warm.
South-west	Cooler.
West and north-west	Moist, rain-bearing. A sharp increase in these winds takes place about the middle of June.
East	Long fine spells (summery).

predicting

weather in the **USA** (general)

WIND FROM	WEATHER
West	High-pressure readings and good weather.
East	Falling barometer and often rain or snow.
North-west	Moist, rain-bearing on the Pacific Coast; elsewhere cold and dry.
Swinging from easterly to westerly	Bad weather improving.
East and south-east	Dry and warm. Prevents depressions.

weather in the **USA** (north-east)

WIND FROM	BAROMETER	WEATHER
SW to NW	Steady	Fair, little temperature change for one or two days.
SW to NW	Fast rise	Fair, followed by rain within two days.
SW to NW	Steady	Continued fair with little temperature change.
NW	Slow fall	Frontal system approaching. Fair for two more days.
S to SE	Slow fall	Rain within 24 hours.
S to SE	Fast fall	Wind rising in force, rain within 12–24 hours.
SE to NE	Slow fall	Rain in 12–18 hours.
SE to NE	Fast fall	Rising wind, rain within 12 hours.
E to NE	Slow fall	In summer, light winds, rain unlikely. In winter, rain in 24 hours.
E to NE	Fast fall	Rain probable in summer in 24 hours. In winter, rain or snow and windy.
SE to NE	Slow fall	Steady rain for one or two days.
SE to NE	Fast fall	Rain and high wind, clearing within 36 hours.
S to SW	Slow fall	Clearing within a few hours. Fair for several days.
S to E	Fast fall	Storm imminent, clearing within 24 hours; colder in winter.
E to N	Fast fall	Severe NE gale, heavy rain in winter, heavy snow.
Going to W	Fast rise	Clearing and turning cool.

looking directly at the moon

Watch the Phases of the moon, because there are weather patterns associated with each phase. By the Middle Ages it was realised that there was no such thing as moonlight; what we see is reflected sunlight. Of all the moonlight that we see, it is still only a tenth of what actually falls on the Moon. And if you were on the Moon you would see earthlight – reflected sunlight bounced off the Earth. The Moon's phases are simply the changing angle that the Moon makes as it is seen at different times between us and the Sun.

Early in the third century BC, Aristarchus of Samos accurately determined the distance of the Moon from Earth by measuring Earth's shadow on the Moon during a lunar eclipse. But it was Galileo who, gazing through his telescopes at an imperfect Moon, realised that real truths about celestial bodies were within man's reach.

There was wide consensus that a Full Moon on a Saturday foretold bad weather, two in one month would bring floods and one at Christmas foretold a bad Harvest; and that pointing at one brought bad luck but getting married under one was lucky. However, much ancient Moon-weather predicting was quite sound. Clearly, though, Shakespeare put little trust in the matter when he wrote:

O! swear not by the moon, the inconstant moon,
That monthly changes in her circled orb,
lest that thy love prove likewise variable.

– Romeo and Juliet

Here are some accurate predictions you can make just by watching the phases.

new Moon (day moon)

New Moon rise always occurs early morning, 6.00–7.30am.

The new Moon and first quarter Moon are always over the hemisphere that is experiencing summer. The new Moon is a day Moon, meaning it is overhead during the daytime hours, which tends to cause clear mornings and evenings, with any cloudiness mainly at midday (unless the Moon is in perigee, which would cause more cloud and possibly daytime rain).

Night skies are mainly clear and cool, even in the summer. If the weather is unsettled and there is rain about, the rain will be mostly in the period of early evening until dawn.

At new Moon time the Moon is travelling fastest in its lunation cycle. The Moon in perigee also acquires considerable extra speed, with the result that if new Moon is close to perigee, the two phenomena will tend to drift closer together. It is as if the new Moon and perigee attract one another. There is maximum gravitational pull at this time, because the Sun and Moon are in line, and the Moon is closest to the Earth for that month. Any night tornadoes usually come at a new Moon.

At this time, the Moon is in the sky from early morning to early evening. It cannot be seen as there is too much sunlight around. It is higher in the sky in summer, which increases the effect of the atmospheric tide (and therefore the likelihood of unpleasant weather) at night. As the new Moon passes through a solstice or maximum declination (22 June or 22 December) it tends to slow, creating a stationary weather system if summer.

If a winter new Moon, there is a likelihood of snow at night.

If accompanied by a Moon in perigee, expect a storm if it's summer, or gusty winds and cloud if it's autumn. On the other hand, if Moon is in apogee, in summer a heatwave is possible. Atmospheric tide is higher in the day, shorter at night.

A new Moon at the time of the March equinox often brings daytime gales.

The new Moon in most old cultures was considered the start of the new month. One man's sole job would be to sit on a hill and sound a trumpet as soon as he saw the thin sliver of the first crescent, signalling the month to begin. Children were taught never to point at it, as this was not only discourteous but also bad luck for the whole month to come. Nor was it deemed propitious to look at the new Moon through glass, or even worse, reflected in a mirror. That first glimpse of the new crescent should be made outside, in the open air. To bow or curtsey to the new Moon was highly recommended and in some countries, bowing several times was strongly advised. So, too, was turning over a silver coin in the pocket at the sight of the first crescent – said to increase one's wealth. This time too, is when one did one's wishing, because it was believed to be the time wishes would be granted.

first quarter (day moon)

First quarter Moon rises just after lunch, sets just after midnight.

This is the most settled phase, storms occurring least between now and Full Moon. It is commonly a time of weakened pole-ward upper-air heat flow. Because of the magnetic shielding effect from the Sun, there is some diminished electrical presence. If a tornado occurs in the early morning hours and up until midday, it is usually when the Moon is in the first quarter. This is the time of the month referred to by the adage 'rain before seven, over by eleven'.

There should be cloud and rain (if any is about) mainly before lunch. Because the atmospheric tide is smaller in the morning during this phase, early morning is the time of the greater possibility of a

tornado, as well as rain and cloudiness. Rain is less likely in the evening. After midnight there may be some lightning and electrical storms. If it is a first quarter Moon in perigee, hurricanes are possible.

In the summer, expect clear mornings with dew on the ground; and in winter, cold mornings accompanied by frost and snow.

Full Moon (Night Moon)

Full Moon rises around sunset and sets around sunrise.

Around Full Moon there is a strong pole-ward transfer of heat to the upper atmosphere, which makes the warmest daily temperature on Earth 0.2° warmer than at new Moon. Also, after Full Moon, as the Moon enters Earth's magnetic tail, there begins more interference with cosmic radiation.

Thunderstorms are frequent a maximum of two days after the Full Moon.

Most tornadoes seem to occur from Full Moon until Last Quarter, because this is the time when the Sun applies the most heat to the ground. There is more likelihood of storm activity in general – that is, hurricanes and typhoons – between full and new Moon than between new and Full Moon.

This is a time for mainly daytime cloud and rain. Lower in the sky in summer, the Full Moon creates a daytime atmospheric tide that is lower. It may rain in the early morning as the Moon sets. Midday may be cloudy, and the afternoon may be a tornado time in some areas. Rain is less likely in the evening. Overnight it will probably be clear.

Whirlwinds, waterspouts and a heatwave are high possibilities just before the Full Moon in summer. In the winter one can look forward to the prospect of daytime snowstorms.

When the Full Moon is in perigee, there is usually an extra-low atmospheric tide effect near midday. If it is summer, very warm temperatures will result. But the Moon in apogee at this time can also bring a possible heatwave. At the solstice the weather patterns slow down.

last (**third**) quarter
(**Night Moon**)

The Last Quarter moon rises around 12 midnight–1am.

There is a greater tendency for electrical storms at this time than at any other Moon phase in the month. The reason probably has something to do with the Van Allen Belt, which is the protective magnetic field encircling Earth from pole to pole; it shields the Earth from too much electrical energy from the Sun. Because the full to Last Quarter Moon is a Night Moon – that is, it is over the opposite hemisphere during the day – by gravitational attraction it pulls the Van Allen Belt towards itself and so, because Earth is in the way, those charged particles are pulled closer to the Earth. During the day the charged particles electrify clouds that have formed because the cold of space has entered the thinner daytime atmosphere. This, again, is often a recipe for an electrical storm.

The Last Quarter is a time of cloudy afternoons and early evening cloud, and at that time too, possible rain. There is also increased ozone (more electrical activity on the upper oxygen), and more meteoric dust, which the Moon pulls from the Sun and towards Earth.

Ice nuclei are more predominant in the sky (which means thunderstorm formation is more likely). Plant growth increases because plants become more electrically charged and have the least protection from the magnetic solar wind around the Sun.

The early morning and midday bring no rain, but in the afternoon showers will fall if rain is about. Evening is a possible time for tornadoes, and afternoon to evening in daylight hours for possible electrical storms. Rain is less likely after midnight.

The Last Quarter Moon can make the summer day very hot and the winter day very cold, especially if the wind comes from the north-east or north-west in the northern hemisphere or south-west to south-east in the southern hemisphere.

Last Quarter Moon in perigee brings an extra-low atmospheric tide in the afternoon. If summer, things will be very warm.

looking directly at the moon

145

Remember the rule: If the Moon is in the sky, there is less likelihood of rain (if about).

The appearance of the Moon in or on the water was once considered a source of magic for good and evil. In India there was a cure for nervous disorders which involved drinking water that had reflected the light of the Full Moon (the vessel was a silver bowl). Interpreted scientifically, this would be the time when the atmosphere was thickest, and oxygen enrichment may at that time provide health and an energy increase.

Note when the Moon rises and sets, because when it is gone from the sky above you, the atmospheric tide effect of a thinner atmosphere where you are comes into force. And keep an eye on the Moon's diameter-size, so you can get a rough idea of the perigee. Then you can work out the date of the next perigee by adding 27 days.

reading
weather maps

Most newspapers publish daily weather maps, distributed by the local meteorological service. The maps are accurate; they come from a vast radar and satellite network.

Usually, teams of media weather forecasters employ three or four different computerised models from at least half a dozen international satellite agencies. Because some contradict others, it is often a matter of deciding arbitrarily which one to use at any given time. If the weather forecast in the morning says it will be a fine day and by lunchtime there is a downpour, then they picked the wrong model. The maps don't lie; it is only the interpretation of them that may be wrong.

what are **isobars**?

Most of us are familiar with the black contours or whorls on every weather map. They signify lines of equal pressure.

Pressure is the force applied to a unit area of a surface. Imagine a narrow column of air going from a drawing pin on the ground right up into the end of the atmosphere, some 65 km (40 miles) vertically. Now imagine what that column of air would weigh bearing down on that small drawing pin, and what the pressure of that weight would be.

Millibars are the units of pressure of the weight of all the air in a supposed narrow column going right up to the top of the atmosphere above any fixed land point. Pressure is measured for one square metre above that point. It is measured in inches or in millibars – smaller units of pressure that measure about a third of an inch. Sea-level pressure is usually around 1000 millibars.

Low pressure at sea level indicates cyclones or storms near the surface of the Earth. This is of course due to the lower atmosphere around that location. High pressure (at sea level) indicates higher air, or calm weather. Low pressure (compared to other locations at the same latitude around the globe) indicates the presence of a storm or trough at mid-troposphere levels. In general, anything below 1016 usually signifies rain. Low pressure may be followed by a depression. Gales in middle latitudes nearly always form around depressions.

A relatively high pressure indicates a ridge and quiescent weather, with light winds. Conversely, decreasing pressure, observed over a couple of days, usually indicates an approaching or intensifying storm. Increasing pressures mainly indicate clearing weather for the period.

anticyclones

Anticyclones – rotation of the winds counterclockwise in the southern hemisphere, clockwise in the northern hemisphere – are associated with calm weather. Anticyclones drift towards the east in both hemispheres.

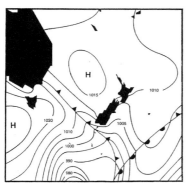

Wind speed is generally light in the centre but can be strong on the outer fringe where it blends in towards a low-pressure zone. Anticyclones are often persistent, as air has had a chance to consolidate, and the whole

The weather map at the time of a heatwave (record summer high temperatures) three days after new Moon, New Zealand, 7 February 1973.

system tends to drift rather than pick up speed. Barometric pressure can rise steadily while an anticyclone is developing, and fall when it is receding.

cyclones

In the southern hemisphere clockwise rotation of winds is associated with cyclones or storms at upper levels and will tend to coincide with troughs in the pressure field. Cyclones and depressions will tend to drift east or south-east.

In the northern hemisphere the situation is reversed: anticlockwise winds indicate bad weather, and clockwise winds show calm and settled periods. Cyclones and depressions will tend to drift east or north-east.

A tropical cyclone is a low-pressure circulation in tropical latitudes, having wind speeds more than Beaufort 8 but less than 12 (hurricane). A hurricane or typhoon is an intense tropical cyclone. It forms and travels over oceans and degenerates to depressions when it reaches land.

The worst cyclone of the twentieth century hit Bangladesh on 13 November 1970. The Full Moon was on the 14th, and the Moon was in perigee on the 11th, three days before. The destruction was widespread, with an estimated million people killed.

Every 20 years (about a Moon cycle) New Zealand experiences an extreme nor'wester. The most famous was in the first week of August 1975, the week of the new Moon, with perigee occurring on the same day. Winds reached 170 km/h (100 mph) and caused destruction across 1300 km (800 miles).

But one particular weather-related disaster stands out in the minds of New Zealanders because it happened within memory.

the **Wahine** disaster

10 April 1968

The meteorological service knew there was a severe tropical depression with central pressure of below 975 millibars, centred 100 km (60 miles) east of North Cape and moving south-south-east at 20 knots. It was predicted to hit the Wellington area the next day, strong northerlies changing to southerlies, increasing to gale or storm force by morning.

The tropical depression or cyclone had already been battering the north of the North Island, as storm warnings that had been out for a week – after causing havoc in the Coral Sea (close to the Solomons), 3200 km (2000 miles) to the north-west – moved down to New Zealand on a north-easterly gale. It was three days prior to a combined Full Moon and perigee. Swollen streams burst their banks and landslides blocked highways. The inter-island ferry *Wahine* struck a reef when attempting to enter Wellington Harbour and, after great difficulty in the height of the storm, foundered opposite the suburb of Seatoun. The vessel was abandoned, but 51 of the 734 passengers lost their lives.

On another day in history, *one Moon cycle before*, bad weather had also battered the South Pacific. Nor was it confined to the Pacific. Storms had raged throughout the United States killing at least 15 people. Trees had fallen in Kansas, crushing two cars. Dust storms and strong winds had crashed a private plane in New Mexico. Winds of up to 170 km/h (100 mph) had swept through Louisiana, Mississippi and Alabama, tearing down communications and damaging buildings. Thunderstorms shook the Ohio Valley and out-of-season snow fell in the north-central states. Hailstorms damaged homes and greenhouses in the northern states. In Ecuador, 50 people were drowned or missing as flood waters of the Tumebamba River swept through the city of Cuenca, collapsing 10 bridges. In Portugal a ferry carrying 130 passengers had sunk in the River Douro after hitting a sandbank, drowning 50 people. More than 100 were killed and another 100 injured in Brazil when a train plunged into the Tangua River, north-east of Rio de Janeiro. Most of the passengers were Easter holidaymakers, sleeping when the train had sped

over a bridge that wasn't there. In Spain, 19 people were killed when two trains collided in atrocious weather. And in England, a minor air crash. In New South Wales, heavy rain had caused flooding that almost totally submerged the town of Warren, population 2000.

It was the same day as the *Wahine* capsizing. Same date. Same position of the Moon (within four days of Full Moon in perigee). The only difference was that it was a lunar cycle before. So could the *Wahine* tragedy conditions have been foreseen? It is worth pondering over. Nothing remotely like those disasters had happened in the week on either side. When it comes to cycles of the Moon, storms do strike in the same place twice. Let's look at the same cycles of the Moon, exactly one Moon cycle *after* that fateful Wellington day. Fortunately, we have the map. As might have been expected, heavy winds again can be seen crossing the South Island.

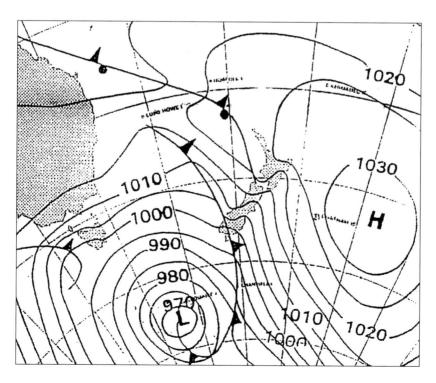

language of **weather maps**

A *front* is the interface between air masses at different temperatures. A warm front is when the air behind the front is warmer than that ahead of it; on a weather map the pips (triangles or half-circles) are put on the side of the front towards which the front is moving. A cold front is when the air behind the front is colder than the air ahead of it.

The map below shows an anticyclone approaching Britain from the south-west, bounded to the west and north-east by stationary fronts.

Triangles = cold front
Half-circles = warm front
Triangle /opposite side half-circles
 = stationary front
Triangles alternating with half-circles on
 same side of line = occluded front

Occluded front: a composite of two fronts, formed when a cold front overtakes a warm front or quasi-stationary front. The point where the occluded warm and cold front comes together is called the *triple point*, an area of extreme instability, and is often where severe storms can be found.

Stationary front: no real temperature change from one side of the front to another, mostly a change in wind direction as the front moves through.

Trough: an elongated area of relatively low pressure, often associated with disturbances such as showers and rain.

High pressure: associated with clear skies, pleasant weather.

Low pressure: associated with clouds, precipitation.

An ascending air motion is associated with cloudiness and rain. High values of relative humidity indicate the availability of moisture. When large rates of ascent are located with high moisture availability, heavy rainfall will probably occur.

Recipe for snow: Just after new Moon, midwinter polar winds from the south-east, sudden weather change associated with a cold front.

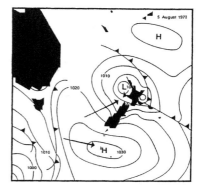

Advection (a localised temperature change) of moisture by the wind can be inferred by noticing the direction and rate at which moist areas appear to be blown. Similarly, temperature advection can be inferred by noticing whether the wind is blowing cold air towards a warm region, or warm air towards a cold region.

The direction of flow of the wind is generally from west to east throughout the middle and high latitudes of both hemispheres, but this doesn't apply to the tropics.

what makes a **thunderstorm**?

Thunderstorms are electrical. Static charges reach the ground as a front passes over, setting the scene for lightning interactions. When the Moon is at north or south declination points, these inter-cloud electrical discharges create rain. But when the Moon crosses the ecliptic during its monthly cycle, if it is generating storms on a fast-moving front, there are more cloud-to-ground discharges, meaning lightning. Thunderstorms are therefore more likely at those declination mid-points – Moon crossing equator – whereas heavy or persistent rain is more common at northern and southern declination points.

Storm over the British Isles on the day of new Moon, 2 August 1978.

153

what is a **tornado**?

Most tornadoes are the product of warm, moist air rising through cooler air and creating highly energised storms called supercells, which give off energy called 'latent heat,' creating an updraft. Then the whole is hit by wind shear – two layers of wind, one moving fast on top, the other slower below it – which spins the updraft wildly, forming a meso-cyclone, a whirling column of air 10 km (6 miles) wide. And then a downdraft at the edge of the meso whips out a tightly wound whirlwind, coiled in the shape of a funnel, blowing at a minimum of 100 km/h (60 mph). The tornado that swept across Missouri, Illinois and Indiana on 18 March 1925 (same day as the perigee), ranks first in distance (350 km – 220 miles), dimension (a mile-wide funnel) and body count (689 dead).

what is a **hurricane**?

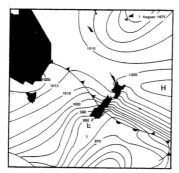

The weather map of a hurricane over the North Island of New Zealand in the same week as a new Moon and perigee.

Isobar lines close together indicate strong winds. Hurricanes are descriptions of wind speed, according to a system called the Beaufort Scale devised by Sir Francis Beaufort in 1802. It ranges from 0 (calm) to 12 (hurricane wind).

The deadliest USA hurricane rolled into Texas in 1900, killing 6000. The costliest hurricane, Andrew, ravaged Florida in 1992, causing $30 billion in damage.

Beaufort Scale

0 Calm (less than 1 mph), smoke rises vertically. Water surface like a mirror.

1 Light air, 1–3 mph, smoke drift. Ripples, no crests.

2 Light breeze, 4–6 mph, wind felt on face, leaves rustle. Small wavelets, crests don't break.

3 Gentle breeze, 7–10 mph, leaves and twigs in constant motion, flags extend. Large wavelets, crests break, 'white horses'.

4 Moderate breeze, 11–18 mph, dust raises, small branches move. Longer waves, frequent white horses.

5 Fresh breeze, 19–24 mph, small leafy trees sway. Moderate waves, chance of spray.

6 Strong breeze, 25–31 mph, large branches move, telegraph wires whistle. Large waves, white foam and spray.

7 Near gale, 32-38 mph, whole trees in motion, hard to walk. Sea heaps up and white foam blown in streaks.

8 Gale, 39-46 mph, twigs break off trees. Waves about 5 m (16 feet) high.

9 Strong gale, 47–54 mph, damage to chimneys and roofing. Waves 7 m (23 feet) high, spray affects visibility.

10 Storm, 55–63 mph, trees uprooted. Sea white, heavy and shock-like,waves 9 m (30 feet) high.

11 Violent storm, 64–72 mph, seldom over land. Waves hide medium-sized ships, foam everywhere.

12 Hurricane, greater than 73 mph. Sea completely white with driving spray.

other weather conditions

Name	When likely	How forms
Dew	Full Moon, waning gibbous, and last quarter	Temperature of the ground drops, causing condensation of the air immediately above it. Needs a still, clear night. Must be high humidity in the air next to the ground, and low humidity in the air just above it. Absence of cloud allows ground to cool enough for most air just above it to condense. In the desert, dew is often the main water source for plants and animals.
Fog	New Moon, first quarter to waxing gibbous	As for dew, but a deeper layer of moist air is required. It is possible to have dew without fog but not fog without dew. Fog is low cloud and forms mainly at night.
Frost	Full Moon to last quarter	On clear nights, when conditions allow for fast cooling to below freezing. (Slow cooling only results in dew.)
Snow	At night: from new Moon to waxing gibbous. In daytime: waxing crescent to last quarter, including first quarter, waxing gibbous, full Moon and waning gibbous.	Freezes in atmosphere before it falls. Ice crystals bond in cloud and then fall through cold air.
Hail		Rapid freezing, drops and melts and freezes again as it encounters warmer and colder air.

q's and a's

Q: You say when the Moon is on the other (away-from-Moon) side of the Earth, what is left (of the air) is narrower over that hemisphere. Why does the atmosphere not bulge like the ocean on the far side of the Earth from the Moon?

A: Gravitation only has a pulling effect and the high water tide on the opposite side of Earth is thought to be caused by the Earth floor on the bottom of the oceans being pulled through the centre of the Earth towards the Moon. This leaves effectively a greater depth of water and therefore a high tide on that side. That plus centrifugal force. So it's not really a high tide, more a low ocean floor. But the atmospheric tide on the away-from-Moon side is due to a different process. The land surface is under the sea, so isn't a factor to alter the tidal height of the air.

Q: It seems to me it would be important to know the shape of the bulging atmosphere, and specifically how the height of the atmosphere on the away-from-Moon side compares to that of the portions at right angles to the Moon, i.e. the 'low tide' zones. Is there any way of judging simply whether the atmosphere on the

away side is lower or higher than that at the sides of Earth – what you'd call the mid-zone atmosphere?

A: I don't think there would be any mid-zone atmosphere. Presumably the atmosphere on the away-from-Moon side is lower than that at the sides of the Earth because the Moon would be pulling the atmosphere, which would to some extent take in the atmosphere at the sides, really in effect leaving only the atmosphere in the whole lower hemisphere lower.

Q: By "mid-zone" atmosphere I meant the air at the sides of the Earth.

A: Yes, I understand that suggestion. But I honestly don't think it's a consideration. The Moon is so far away it would be the atmosphere above the Earth or below it, only two groups so to speak. I don't think anyone has ever imagined that air would stick out at the sides.

Q: I feel you've not quite got my point about the sides. I don't mean to suggest the air 'sticks out' – it's there (and less of it), like water at low tide. But I'm curious about whether there's less 'there' (at the sides of the Earth–Moon line) than what remains on the far side.

A: In my mind an analogy would be a torch shining on a basketball. All the top hemisphere would be illuminated and the back side would be in darkness. The transition point would be at the 'equator' and would just be an imaginary line, not any sort of band. There would not be a halfway situation where it would be half-lit at the sides or even a level of dark at the sides that could be compared to the underneath. That just isn't the physics of a sphere.

The bulge on the near-to-Moon's side is just a greater volume of gases, that's all, and therefore it would be 'higher' in height. The atmosphere can move very quickly to be under the Moon; quicker than the Moon itself travels. There is just *more* atmosphere in that region of sky. The Earth's gravity still pulls it to *us* so it is stretched on the near-to-Moon side – therefore higher pressure – because

there is more of it and the portion closest to Earth is pulled towards Earth by Earth's gravity. The *upper parts* of the atmosphere get stretched more towards the Moon – that is, the upper part that is farthest from Earth's gravitational influence. That's why high-pressure weather systems accompany the Moon and why it is less likely to rain when the Moon's there. The Earth, of course, is travelling at 1600 km/h (1000 mph) in rotation. The atmosphere is too, or we would be encountering all sorts of climate zones in the course of a 24-hour day. And our weather overhead is always travelling with us, due to our gravity. The Moon's gravity is always working against ours. So the same piece of atmosphere must get stretched and then released in the course of the day as we and our weather together move under the Moon's influence and then away again. That's what happens to the water, too. What makes it low tides at the sides of the Earth is a default situation – there is only so much water, and the high tides are on 'top' and 'underneath'(for want of a better concept) and because there is a fixed amount of water, it gets depleted from the sides. With water and Moon we are talking volume distribution. But water is noncompressible; when it is pulled, it just goes all together in a liquid lump. With a gas we're talking mass distribution too, yes, but that translates quickly into pressure distribution because gases can be compressed and stretched. So when atmosphere is lowered from the away-from-Moon side of the Earth because the Moon is pulling on the opposite side, the underside is going to lose some height, and become heavier and compacted at lower levels. Hence clouds come and go as to the time of day, which they appear to do.

Q: I take it the term 'stretched' refers to the atmosphere's height, as if we were talking of the thickness of the skin of an apple or an orange – not its molecular density. But isn't height the same as pressure?

A: The idea of stretched is not necessarily molecular density; rather an area distribution. If it's stretched it would be thinner only if it

couldn't redistribute from somewhere else. Gravity acts only on mass. On the away-from-Moon side of the Earth the area holding the atmosphere is still a sort of closed container – its limits are set by Earth's gravity and its volume by centrifugal force. So there's the same volume of air on each side of the Earth all the time, but on the away-from-Moon side it's heavier and more compacted, so lower in height; meaning the cold of space can more easily penetrate closer to the ground. On the near-to-Moon side, there is still as much air, but it is higher, which means more evenly spread out rather than have a lump of it closer to the ground.

Q: *But gravity has an effect on density too, doesn't it?*

A: Gravity has less effect on density than the Moon has on atmospheric height, which is why steam drifts up away from Earth once it has vaporised. Just because the atmosphere might be lower doesn't mean there is no air down near the ground on the lower side.

Q: *Why should a topdressing aeroplane be more careful than an airliner about where and when it flies during the course of the day?*

A: Because topdressing planes use propellers and airliners don't. The jet is not affected by atmospheric height because all that makes the jet go forward is the opposite reaction of the jet-thrust moving backwards.

Q: *Do the pilots who survive crashes speak of losing buoyancy – or can other causes always be found?*

A: In flying small planes over relatively short distances, pilots are interested in avoiding low cloud, very strong winds, and thunder and lightning. Aviation people use the barometer to look for rapid change of pressure as an indicator of a time to stay on the ground. What I think they really want to measure is changes in the 'lapse rate' – temperature changes with altitude. If the temperature changes

as you climb are different from normal, then you will probably get instability, as the unusual lapse rate is likely to be over a small geographic area. I think this is what causes things like thunder clouds. It seems that the met service are almost completely incapable of predicting this at a distance.

A wing's performance is certainly directly related to the pressure of the static air around it. Then to velocity through the air, angle of the wing's chord to the still air, and the shape of the aerofoil control, the amount of lift, or lack of same. Close to the ground other factors come in, too, like 'ground effect' – the lifting effect of the wave from the wing striking the ground and being reflected up against the wing again, and all sorts of super micro-effects like turbulence around vegetation and wind speed slowing due to friction with the ground, etc.

Low atmospheric pressure means longer take-off runs, lower rate of climb, and less performance all round. This means safety margins are decreased. In aviation terms it is called 'pressure altitude'. Depending on the current air pressure the manufacturers of aircraft publish performance tables based on various 'pressure altitudes'. These are expressed in feet or metres above standard sea level – 1013 millibars and I think 13°C at sea level. The pilot translates according to the prevailing conditions. It takes only small changes in temperature and pressure to make big changes in performance, as a number of pilots have learned as their last lesson. Pilots usually translate this as 'be careful if your airport is high' (something like 3000–4000 feet means rework all the numbers and probably have a test flight with a local instructor), but at constant temperature every 33 feet of elevation is a decrease of 1 mbar pressure, so even the normal range of air pressure causes dramatic performance changes. When you get higher and the temperature drops down, the air gets heavier and cold air falls, therefore creating what pilots would interpret as aviation instability. Clouds descend lower in a low air tide, and remain higher in a high tide.

Q: I think if you use the phrase 'atmospheric tides', your readers should get a clear idea of the similarities and differences between water and air when they are pulled. For example, doesn't water change its density?

A: It does when it gets colder or hotter and when it turns to steam.

Q: Actually, I'm still puzzling. Air on the away-from-Moon side is being pulled in the same *direction by Earth and Moon – it should be getting denser...*

A: Don't forget centrifugal force, working against gravity trying to heave everything off the Earth and into space on the away-from-Moon side. Gravity wins of course and the sea stays on. The Moon's gravity is there too, but not as strong as the Earth's. Otherwise all the sea would bunch up on the Moon's side all the time. Same for the atmosphere on the away-from-Moon side. But the gravity of the Moon on the near-Moon side pulls a lot more air around to there than gravity can hold onto on the away-side. What remains on the away side is held there by centrifugal factors and gravity.

Q: Since your thesis depends on the Moon pulling the air, I don't think it's enough to presume about the thickness of the air on the sides and far side of the Earth. You're talking to the world about its rain – it's got to wash. We can picture the ocean's bulge and its causes. There has to be a way found to picture the atmosphere's bulge – by experiment or measurement or mathematical model – or an airtight line of reasoning.

A: It's difficult to prove this. But the same forces that give two sea-tides each day must have a similar effect on the atmosphere. What the effect will be is much harder to pin down than going down to the sea and watching the high-water mark. Don't forget the Moon is also going through various phases in its orbit. The phases are also taking place as the Moon shifts north and south criss-crossing

the equator into each hemisphere. So the atmospheric high or low tides will similarly take place wherever and however the Moon is in place. That's hard to prove to everyone's satisfaction. The lunar tide is there, but there is no way the tide can be seen. One can only infer, by logical deduction, that it has to be there.

Q: *I'm not doubting your atmospheric tides – and I note you saying the effect will be hard to pin down – but somebody's going to make it visible.*

A: Scientists know about subatomic particles by the effects they cause. It seems they don't have to see them to form theories that are workable. I can't see New York, but logic tells me it's there.

Q: *You suggest that air on the far side forms a* low *tide – but is it lower than the atmospheric tide on the sides of the Earth – or higher? Would this question not have a direct bearing on precipitation?*

A: I don't think one can compare the properties of water with that of gas. Sure, we're talking tides, but it only gets similar in the fact that the Moon pulls both. The Moon pulls the solid Earth, too, but we have no practical need for a high Earth mark. My way of considering this is to think of just the upper situation as it compares with the lower; bearing in mind that a whole lot more is going on, what with the Earth turning and the Moon turning and traversing the equator at the same time.

Q: *Do low-pressure areas mean a higher atmosphere?*

A: A low-pressure air system can raise the height of the water tide more than it would normally be, because the atmosphere is not pressing down on the water surface so much, so allowing the level to rise. And this high-water tide would be the one on the away-from-Moon side of the Earth, where the atmosphere is lower, not higher.

Q: Do high pressure areas mean a denser atmosphere?

A: I prefer to say higher atmosphere and more even in its spread.

Q: The Moon's bulge doesn't change the pressure?

A: No, it doesn't show on the barometer, which is why most scientists say there isn't any bulge.

Q: So the Moon overhead must make the air both less dense and higher at the same time? Is that what the bulge means?

A: Yes! Same pressure, higher, more of it, but only more compacted on the away-from-Moon side!

Q: Are you actually 'looking at the Moon' when you predict the weather or looking at weather maps of earlier days?

A: I'm looking at the Moon for the phases, at the size for the perigee proximity, and whether or not it's in the sky. That gives me a rough read for the next few days. But for the details I go to past weather maps. I look at *last* month around the same time of *this* month – weather will be similar. I look at *last year* where the Full Moon and perigees match for *this* month – weather is generally similar. Then I look back at the 19-years-ago maps and search for matching full/new/perigee/apogee settings, coinciding with northern and southern declinations. It is amazing how similarly they overlay with the current year. I could pick any 18–19 year cycles, that is 36–38 years ago as well, as I have all those maps. There's a little more variation, but not all that much, the further back you go. Then I look at what I have and average it subjectively. I find the anti-cyclones are very reliable and predictable; they repeat their patterns exactly. But depressions are somewhat temperamental and may for instance stay up north-west of New Zealand when I'd expect them to come down. Or they may shoot backwards to Australia, hang around for an extra day or two and then come firing full pelt into

the middle of New Zealand!

Q: *I find it astonishing that such a difference exists between near-side and far-side atmosphere.*

A: I suppose no more astonishing than the sea tide.

Q: *Are there any photographs showing the air's Moon bulge? A satellite taking pictures of the Earth during a major burn such as of oil (as in the Gulf War) or forest or explosion such as volcanic eruption will show the air made visible by the smoke. The same satellite might show the bulge made visible by cloud as well.*

A: We'd need to have at least two photos taken of the same place within a 24-hour period. They'd have to be infra-red, to take care of the absence of light. But we don't have to even do that. A circle of cloud around a pinnacle-shaped hill moving up or down in altitude would be acting as a giant barometer.

Q: *I imagined that the size of the Moon might mean that 60 per cent of the atmosphere might be on the near-Moon-side hemisphere but the way you describe it, there would be over 95 per cent. You don't mean 20 per cent, you mean 20 per cent more don't you? After all, without any Moon pull, there's already 50 per cent on the near-Moon's side. But 20 per cent more of what's already there (bringing it to 60 per cent) – or 20 per cent of the total atmosphere more (bringing it to 70 per cent)?*

A: Yes, 20 per cent more. I'd say over 20 per cent. But that would be significant, twice a day. It's probably what it is for the water tides, too. Of course they vary so much there's probably no fixed percentage.

Q: *And I'm missing something. Twice a day? Is the Moon not close over me only once a day?*

q's and a's

165

A: Yes, but the other side of the world gets the other tide at that time. So two atmospheric tides per day if we think of the world being composed of two hemispheres.

Q: Since air moves so much faster than water, wouldn't the percentage of air shifted be much greater than the percentage of water shifted?

A: You'd think so, because gravity wouldn't act as much on the air to stop it moving from the away-from-Moon side. Which means the water tide probably isn't as much as 20 per cent.

Q: How did you calculate one Moon cycle? The dates you gave aren't 18.6 years apart.

A: Anything from 17 to 19 years. It varies. I look for the same orbital factors combining together within six months or so.

Q: When you write 20 per cent, and compare the tides to the ocean tides, that seems to contradict your whole torch analogy, in which the air is in a one-hemisphere-or-the-other state. It puzzles me.

A: I think the 'side bits', your mid-zone idea, would have relevance here. On moonrise or moonset about 20 per cent of atmosphere is either being returned or taken, on the mid-zones the Moon was coming through and leaving (actually it is the Earth doing the moving, with a relatively still Moon, much as the Sun doesn't set – *we* roll out). Applying the torch-on-ball idea, the torch would just be shining on a turning ball.

Q: Can you tell where north and south is from looking at the Moon?

A: The Moon generally rises in the east and sets west or north-west. When full, the Moon is opposite to the Sun in the sky, and to observers in the northern hemisphere of the Earth it lies due south at midnight. For those watching from the southern hemisphere, at midnight the Full Moon lies due north.

Q: *I think a lot of our early history must come from what is now below sea level locations, proving that the sea levels in the past must have risen a lot.*

A: I disagree. The fact that the Earth may subside and sink due to all sorts of factors, even simple erosion, muddies the search for what really happened. It is too easy to jump to a scenario of oceans rising. But even if they did, it was in a pre-industrial age before emissions and so greenhouse claims just don't apply. The whole debate revolves around the need or not to cut back on fossil fuels. If the Earth indeed underwent these massive changes way back then, and we are just in a movie rerun, then all global warming talk as a possible cause of things is pointless.

Q: *A figure that I learned just in the time that I last wrote you is that the world's oceans have warmed 0.6°C in the past century... it was the result of research done by an American using old ship records of temperatures taken at sea.*

A: 0.6°C in a century? That's a *lot*? You're kidding me, surely. How did the measurer get around *all* the oceans at the *same time* to get his initial reading? He would have had to use the same thermometer to get a correct result, because thermometers can vary. They must have had faster ships in those days than they have now. 0.6°C can't even be seen on any thermometer that I've ever seen. And I would suggest to you they might have been satellite readings. It was mentioned in a newspaper report put out by NASA that *satellite* figures are for 0.6°C over a century, but this was described as being within fluctuations from expected natural causes.

Q: *If the oceans are warming, just the expansion of the water itself could cause some rising of sea level, and cause ice to break off faster from ice shelves.*

A: But the poles will always be frozen, because of the lower atmosphere

there. But okay, let's imagine a warming: a rise of 3°C is enough to cause an ice age, apparently. It's going to make no difference at the poles, unless you are saying that –32°C going up to –29°C is going to radically change things in that neck of the woods.

Q: At least in this corner of the Pacific there are indicators that point to a warming, I understand most other large areas of ocean do, too. For instance, some species of fish and animals are moving further north into the higher latitudes. Are you aware of Charles Keeling's work with rising cold in the oceans, to cool the atmosphere above?

A: Firstly, I have not heard of any species moving further south around here. Secondly, yes, I am aware of Charles Keeling, University of California, inventor of the greenhouse scenario 40 years ago. Writing in *New Scientist* (1 April 2000), he does claim that strong tides will cause cold ocean water to rise up and cool the atmosphere above it. Weak tides will apparently reduce this mixing, keeping the cold at the bottom, allowing the world to warm. Apart from the discovery of a new scientific principle which is that cold (rather than heat) now apparently rises, I would have to say it is one of the sillier statements I have read in a while. 'Allowing the world to warm.' Is this science? The cold has always been at the bottom. One might just as well say that the cold being at the bottom of my fridge is allowing the world to warm.

Q: Of greatest interest to me is how your South Island glaciers are doing. They, to me, would seem to be a good climate change indicator. Do you have data about them?

A: Some scientists flew over them recently and reported in the *New Zealand Herald* that a rocky ridge was now visible that was last visible 20 years ago. The snowline had now apparently receded to that mark again. But I have a cutting in which scientists from the same organisation claimed in 1989 that the glaciers were at lower

levels than ever recorded. The simple fact is that it is now at the end of summer – there has been no rain down there. But the main point is that from 1980 to 1989 and then till now, the snowline magically restored itself. Otherwise there would be no snow there at all by now. So aren't we just looking at a cycle? We should not be just concentrating on the scare aspect of high snowlines, when a cycle mindset might reveal normal fluctuation.

Q: Do you have any figures for the percentage of the Earth inhabited by people? It seems to me that pollution would be proportional to population.

A: About 90 per cent of the Earth's people live on 10 per cent of the land. As the land, excluding the poles, is about 20 per cent of the planet, the rest being ocean, we have one-tenth of 20 per cent, which is about 2 per cent being inhabited. Additionally, about 90 per cent of the people live north of the equator. We can get a little closer by doing the following maths: the population density of the planet (including all land area) is about 104 people per square mile. Let's say 60 per square kilometre. The surface of the Earth is 432 million square kilometres. Now we say four billion (the Earth's population) divided by 60 to give us populated land in square kilometres, divided by 432 million, expressed as a percentage = 1.4 per cent. That means 98.6 per cent of the world is people-free. Earth is virtually uninhabited. I know that seems unbelievable but my source for this information was on http://geography.about.com/education/geography/msub24.htm

Q: You say chloroflurocarbons (CFCs) are five times heavier than air, so couldn't float up to the ozone layer. How much heavier than air are salt, dust and other particles that raindrops and snowflakes form on? If they are in the same weight range as CFCs and if they get high up, then CFCs probably do also.

A: I think it's wishful thinking on the part of those who don't want to

let go of the pollution scenario, to suppose that all those particles might make it to Antarctica (rather than the Arctic for some strange reason). Given that mankind lives on less than 2 per cent of the Earth's surface, which is where CFCs can only originate from, as against the vast ocean surfaces which can give up salt, and the vast deserts which can offer dust – you would think that the detectors down around the South Pole would mainly report finding dust and salt and proportionately far less chlorine. But no. It seems chlorine is the preferred find! That suggests that dust and salt go elsewhere and CFCs take the long trip to the Antarctic to dump their chlorine. All I can say is that scientists must be very clever to be able to tell apart Mt Erebus chlorine from far-off, travel-weary northern hemisphere CFC chlorine.

Q: Since the world has been warming since the industrial revolution I do not see how the lunar cycle of less than 19 years fits in. It has been a lot longer than 19 years since the start of the industrial revolution.

A: The cities have grown larger with more asphalt and this has had a heat retention factor... cities getting warmer as expansion continues. That's not the world. That's 2 per cent of the world, if that. I dispute that the world has been heating since the industrial revolution. All climatologists agree that between 1940 and 1980 everything cooled, and some were calling it a mini ice age. They can't seem to make up their minds if the world is heating or cooling. Whatever it's doing, they're bound to say it's due to greenhouse gases in some way rather than look to the Moon for an explanation.

Q: If ozone depletion is not a factor, how do you explain higher skin cancer statistics in New Zealand compared with northern hemisphere countries?

A: I think UV rays would indeed contribute more to skin cancer down in New Zealand because in the more industrialised centres with heavier population generating more fumes and dust, air pollution

would act more to keep out the sun's destructive rays. Dust in the air certainly acts as a protection! In New Zealand there is less such pollution-protection, and being a thin ribbon of land which the wind sweeps over in a day, any industrial dust is blown off quickly. But there are other factors. People in these modern times spend less time outdoors as part of their employment, which means that when they do go out they have not built up much skin immunity from the sun. An increase in population plus increased awareness and reporting on that awareness would also inflate skin cancer statistics. You would have to get those variables out of the way before you started looking at ozone levels.

Q: What would it take to melt the poles?

A: The *only* way the poles will ever melt will be if they change geographically. A shift of only ten degrees towards New Zealand would probably mean the South Island would be uninhabitable. So it would take a giant meteoritic impact or similar, something more calamitous than a bunch of people squirting fly spray around a few major cities, to get the poles to change.

Q: *Then you do not say for how long or how much cooling will go on after 2006.*

A: The warming will begin being noticed around 2004. There will be a three-year turnaround, taking us up to 2007. By 2008 we'll be starting to cool again. By 2014 we'll be back into the freezing winters and heat-wave summers of 1997.

Q: The only people who have been saying what you have been saying about global warming are Republicans who have a vested interest in continuing their dirty ways making more money in the short term while ruining the environment in the long term.

A: I have no vested interest in anything other than truth. If it coincides

with what someone stands to make money out of, that's not my concern. I don't believe in prohibition. That doesn't mean I am sympathetic to or in any way in league with large brewery interests. And I'm certainly not sympathetic with anyone ruining the environment. But I would like to see irrefutable evidence of that.

Q: *Photos from the late nineteenth century show a much different snowline and glacial pattern than photos of the same areas taken now. Isn't this pattern consistent all over the world?*

A: Sure, because fresh snow has fallen over the years. Doesn't mean there's less of it.

Q: *The April 2000 issue of the magazine* Sky & Telescope *(pub. Sky Publishing Co., Cambridge, Massachusetts) has a very nice piece of scholarship concerning one of Chaucer's tales in which there is an exceedingly high tide. In December of 1340 all five of the factors which affect the tides were at a maximum: the winter solstice, the Earth at perihelion, the Moon at ascending node, lunar perigee and the new Moon, solar eclipse. The tale takes place on the coast of Brittany, well known for its tides. The authors do a convincing job of historical, literary detective work and computer calculation. Can you confirm they were on the right track?*

A: They sure were. Lunar perigee and new Moon for December 1340 was 19 December, at 10.50am. The Moon was the closest for the year, being 356,904 km from Earth. As a comparison, on 22 December 1999 the perigeal distance was 356,654 km. In other words, last year the Moon was closer. Nevertheless, similar floods that occurred in France last year would have *certainly* occurred in Brittany in 1340. That is very useful information.

Q: *The grand planetary alignment of 5 May 2000 was apparently going to put a lot of strain on the Sun. What exactly was the predicted damage on Earth?*

A: Here's what I predicted: Jupiter's tidal attraction will raise the Sun's surface by exactly one millimetre – hugely catastrophic, not only for the people living on the Sun, but for us down on Earth. On the Sun will be mighty tsunamis with great waves of that millimetre high, which will swamp all helium in their furious path for at least a further millimetre. Here on Earth the situation will be slightly less drastic, but equally worrying, adding an extra half millimetre to sea tides around the world. All islands that poke out of the water by half a millimetre will be completely swamped by the raging water. What carnage to those extremely low-lying metropoli! One can only begin to imagine the chaos that will ensue from an almost perfectly flat surrounding sea. Already our waters are apparently rising by a millimetre a year due to global warming. Of course the poles are melting, too, which means that the temperature must have gone up in Antarctica in the last couple of years from −32°C to + 4°C (the temperature ice requires to melt). Most countries must really be by now around 60°C in the shade. This massive temperature increase seems to have selectively affected only meteorologists. But perhaps the biggest danger will be when everyone yawns at once, choking our cities with CO_2.

Q: Does the idea that Earth has a heat budget, that whatever comes in must be radiated out, and of how the seas and atmosphere accomplish this, now have to be changed?

A: Yes, everyone is still hooked into the old 'atmospheric engine' scenario that the textbooks trot out, where the warm air rises at the equator and cold polar air rushes in to replace it, that being the cause of our weather. But if that were the case the weather would always be the same, because the Sun's heat is constant as is Earth's rotation. Yet the atmosphere *is* broken up and moved around, and now and then offers more or less protection from the Sun's heat and the cold of space. There is only one thing that can break the atmosphere up: the Moon. And we do take it for granted because when you see something

often enough, you stop seeing it!

If it weren't distributed by the Moon daily, all of the atmosphere would end up on the Sun's side because the Sun would be the only body in space with any gravitational pull. There would be one giant cloud always on the Sun's side. We would therefore never see the Sun for the constant cloud. Nor trees, which need direct Sun's rays or they can't photosynthesise. That means they could not produce oxygen which is so essential to life and our existence. So without the Moon there could be no life on Earth. When we are looking in space for evidence of life on other planets, scientists sometimes miss the fact that we should be looking for a planet that has a Moon just like ours. It is one of the most appalling gaffes of modern-day science: to factor the Moon out of every weather computer-model.

appendices

monthly declination data for the **year 2000**

Month	Northern Point	Crossing Equator Heading South	Southern Point	Crossing Equator Heading North	Northern Point	Crossing Equator Heading South	Southern Point
Jan			6	13	19	26	
Feb			2	9	16	22	29
Mar				8	14	21	28
Apr				4	10	17	24
May				1, 29	8	14	21
Jun	4	10	18	25			
Jul	1	8	15	22	29		
Aug		4	11	19	25	31	
Sep			8	15	22	28	
Oct			5	12	19	25	
Nov			1	9	15	21	29
Dec				6	12	19	26

monthly declination data for the **year 2001**

Month	Northern Point	Crossing Equator Heading South	Southern Point	Crossing Equator Heading North	Northern Point	Crossing Equator Heading South	Southern Point
Jan	9	15	22	30			
Feb	5	11	18	26			
Mar	5	11	18	25			
Apr	1	7	14	21	28		
May		5	11	19	25		
Jun		1	8	15	22	28	
Jul			5	13	19	25	
Aug			1	9	16	22	28
Sep				5	12	18	25
Oct				2, 30	9	15	22
Nov				26	6	12	18
Dec	3	9	16	23	30		

perigee, apogee, full moon and new moon in **2000**

Perigee	Order of closest perigees to Earth	Apogee	Full moon	New moon
Jan 19	4th	Jan 4	Jan 21	Jan 6
Feb 17	8th	Feb 1	Feb 19	Feb 5
Mar 14	12th	Feb 28	Mar 20	Mar 6
Apr 8	11th	Mar 27	Apr 18	Apr 4
May 6	7th	Apr 24	May 18	May 4
Jun 3	3rd	May 22	Jun 16	Jun 2
Jul 1	1st	Jun 18	Jul 16	Jul 1
Jul 30	2nd	Jul 15	Aug 15	Jul 31
Aug 27	6th	Aug 11	Sep 13	Aug 29
Sep 24	10th	Sep 8	Oct 13	Sep 27
Oct 19	13th	Oct 6	Nov 11	Oct 27
Nov 14	9th	Nov 30	Dec 11	Nov 25
Dec 12	5th	Dec 28	Jan 9 (2001)	Dec 25

perigee, apogee, full moon and new moon in **2001**

Perigee	Order of closest perigees to Earth	Apogee	Full moon	New moon
Jan 10	2nd	Jan 24	Jan 9	Jan 24
Feb 7	1st	Feb 20	Feb 8	Feb 23
Mar 8	6th	Mar 20	Mar 9	Mar 25
Apr 5	9th	Apr 17	Apr 8	Apr 23
May 2	12th	May 15	May 7	May 23
May 27	11th	Jun 11	Jun 6	Jun 21
Jun 23	8th	Jul 9	Jul 5	Jul 20
Jul 21	5th	Aug 5	Aug 4	Aug 19
Aug 19	3rd	Sep 1	Sep 2	Sep 17
Sep 16	4th	Sep 29	Oct 2	Oct 16
Oct 14	7th	Oct 26	Nov 1	Nov 15
Nov 11	10th	Nov 23	Nov 30	Dec 14
Dec 6	13th	Dec 21	Dec 30	Jan 13 (2002)

bibliography

articles

Adderley E.E., Bowen E.G. and Rodes L., 'Lunar component in precipitation data', *Science*, 1962, vol. 137, pp. 749–750.

Anderson K.A., 'Energetic electron fluxes in the tail of the geomagnetic field', *Journal of Geophysical Research*, 1965, vol. 70, pp. 4741–4926.

Atkinson G., 'Planetary effects on magnetic activity', *EOS Abstracts*, 1964, pp. 630–631.

Axford W.I. and Hines C.O., 'A unifying theory of high-latitude geophysical phenomena and geomagnetic storms', *Canadian Journal of Physics*, 1961, vol. 39, pp. 1433–1464.

Balling R.C. Jr and Cerveny R.S., 'Influence of lunar phase on daily global temperatures', *Science*, 1995, vol. 267, pp. 1481–1483.

Balling R.C. Jr and Cerveny R. S., 'Impact of lunar phase on the timing of global and latitudinal tropospheric temperature maxima', *Geophysical Research Letters*, 1995, vol. 22, pp. 3199–3201.

Barraclough O.R. et al., '150 years of magnetic observatories: Recent researches on world data', *Surveys in Geophysics*, 1992, vol. 13, pp. 47–88.

Bell B. and Defouw R.J., 'Concerning a lunar modulation of geomagnetic activity', *Journal of Geophysical Research*, 1964, vol. 69, pp. 3169–3174.

Bell B. and Defouw R.J., 'Dependence of the lunar modulation of geomagnetic activity on the celestial latitude of the Moon', *Journal of Geophysical Research*, 1966, vol. 71, pp. 951–957.

Beynon W.J.G. and Winstanley E.H., 'Geomagnetic disturbance and the troposphere', *Nature* 1969, vol. 222, p.1262–1263.

Bigg E.K., Influence of the planet Mercury on sunspots, *Astronomical Journal*, vol. 72, pp. 463–466.

Bigg E.K., 'The influence of the Moon on Geomagnetic disturbances', *Journal of Geophysics Research*, 1963, vol. 68, pp. 1409–1413.

Bowen E.G., 'Lunar and Planetary tails in the Solar Wind', *Journal of Geophysical Research*, 1964, vol. 69, p.4969–4974.

Bradley D.A. 'Tidal components in hurricane development', *Nature*, 1964, vol. 204, pp. 136–138.

Bradley D.A, Woodbury M.A. and Brier G.W., 'Lunar synodical period and widespread precipitation', *Science*, 1962, vol. 137, pp. 748–749.

Brier G.W., 'Diurnal and semidiurnal atmospheric tides in relation to precipitation variations', *Monthly Weather Review*, 1965 vol. 93, no. 2, pp. 93–100.

Carpenter T.H., Holle R.L. and Fernandez-Partagas J.J., 'Observed relationships between lunar tidal cycles and formation of hurricanes and tropical storms', *Monthly Weather Review*, 1972, vol. 100, pp. 451–460.

Davidson T.W. and Martyn D.F., 'A supposed dependence of geomagnetic storminess on lunar phase', *Journal of Geophysical Research*, 1964, vol. 69, pp. 3973–3979.

De Freitas C., 'Scientists too often outrageously wrong', *New Zealand Herald* 11 March 1999

Dodson H.W. and Hedman E.R., 'An unexpected effect in solar cosmic ray data related to 29.5 days', *Journal of Geophysical Research*, 1964, vol. 69, pp. 3965–3972.

Dyre J.C., 'Lunar phase influence on global temperatures', *Science*, 1995, vol. 269, pp. 1282–1285.

Erlewine M., 'Science and the Lunation cycle' 1998, http://www.thenewage.com/Root/NA/cycle.htm

Erlewine M., 'Tidal Vector Forces' (See Web page, as above).

Fraser-Smith A.C., 'A possible full-Moon enhancement of hydromagnetic emission activity', *Journal of Geophysical Research*, 1969, vol. 74, pp. 2987–2995.

Greaves W.M.H. and Newton H.W., 'On the recurrence of magnetic storms', Monthly notices of the Royal Astronomical Society, 1929, vol. 89, pp. 641–646.

Gribbin J. 'Planetary alignments, solar activity and climatic change', *Nature*, 1973, vol. 246, pp. 453–454.

Hanson K. G., Maul A. and McLeish W., 'Precipitation and the lunar cycle: phase progression across the United States', *Journal of Climate and Applied Meteorology*, 1987, vol. 26, pp. 1358–1362.

Haurwitz B., 'Atmospheric tides', *Science*, 1964, vol. 144, pp. 1415–1422.

Haurwitz M.W., Yoshida S. and Akasofu S.I., 'Interplanetary magnetic field asymmetries and their effects on polar cap absorption events and Forbush decreases', *Journal of Geophysical Research*, 1965, vol. 70, pp. 2977–2987.

King J.W., 'Solar radiation changes and the weather', *Nature*, 1973, vol. 245, pp. 443–446.

King J.W. 'Weather and the Earth's magnetic field', *Nature*, 1974, vol. 247, pp. 131–134.

Levengood W.C., 'Factors influencing biomagnetic environments during the solar cycle', *Nature*, 1965, vol. 205, p.465–470.

Lin R.P. et al., 'Lunar surface magnetic fields and their interaction with the solar wind: results from Lunar Prospector', *Science*, 1998, vol. 281, pp. 1480–1484.

Lund I.A., 'Indications of a lunar synodical period in United States observations of sunshine', *Journal of the Atmospheric Sciences*, 1965, vol. 22, pp. 24–39.

MacDowall A.B., 'The Moon and wet days', *Nature*, 1901, vol 64, pp. 424–425.

Monastersky R., 'Ancient tidal fossils unlock lunar secrets' *Science News,* 1994, vol. 146, no. 11, p 165, 10 September 1994.

Michel F.C., Dessler A.J. and Walters G.K., 'A search for correlation between Kp and the lunar phase', *Journal of Geophysical Research*, 1964, vol. 69, pp. 4177–4188.

Ness N.F., 'The magnetohydrodynamic wake of the Moon', *Journal of Geophysical Research*, 1965, vol. 70, pp. 517–534.

Ness N.F., 'The Earth's magnetic tail', *Journal of Geophysical Research*, 1965, vol. 70, pp. 2989–3005.

O'Mahony G., 'Rainfall and Moon phase, Quarterly Journal Royal Society of London, 1967, vol. 91, p.132, 137.

Pickering W.H., 'The Moon's phases and thunderstorms', *Nature*, 1903, vol. 68, p. 1232.

Poincare A., 'Air-pressure and the Moon', *American Meteorological Journal*, 1887–1888, vol. 4, pp. 531–532.

Reiter R., 'Increased influx of stratospheric air into the lower troposphere after solar Ha and X ray flares', *Journal of Geophysical Research*, 1973, vol. 78, pp. 6167–6172.

Roberts W.O. and Olson R.H., 'Geomagnetic storms and wintertime 300-mb trough development in the North Pacific–North America Area', *Journal of the Atmospheric Sciences*, 1973, vol. 30, pp. 135–140.

Sapir M. 'Lunar phases and climatic puzzles', *American Scientist*, 1996.

Schmid R.E., 'Gases at the Moon's edges', ABC news.com 1998.

Schuster A., opening address, subsection of astronomy and cosmical physics, *Nature*, 1902, vol. 66, p.614–618.

Shaffer J.A., Cerveny R.S., and Balling R.C., Jr 'Polar temperature sensitivity to lunar forcing?', *Geophysical Research Letters*, 1997, vol. 24, pp. 29–32.

Shapiro R, 'Geomagnetic activity in the vicinity of sector boundaries', *Journal of Geophysical Research*, 1974, vol. 79, pp. 289–291.

Snyder C.W. and Neugebauer M., 'The solar wind velicity and its correlation with cosmic-ray variations and with solar and geomagnetic activity', *Journal of Geophysical Research*, 1963, vol. 68, pp. 6361–6370.

Stolov H.L. and Cameron A.G.W., 'Variations of geomagnetic activity with lunar phase', *Journal of Geophysical Research*, 1964, vol. 69, pp. 4975–4982.

Stubbs P. 'Why should the Moon affect the weather?' *New Scientist*, 1963, no. 329, pp. 507–509.

Twitchell P.F., 'Extra-terrestrial influences on atmospheric circulation', *Bulletin America Meteorological Society*, 1965, vol. 46, no. 10, pp. 641–643.

Vovk V.Ya., Yegorova L.V. and Moskvin I.V., 'Evaluation of correlation between variations of absorption of cosmic noise and near-Earth atmospheric pressure in Antarctica', *Geomagnetism and Aeronomy*, 1993, vol. 34, p.118–120.

Wilcox J.M.et al., 'Solar magnetic structure', *Science*, 1973, vol. 180, pp. 185–186.

Wood K.D., 'Sunspots and Planets', *Nature*, 1972, vol. 240, pp. 91–93.

books

Alcock H., *The Lunar Effect*, Moana Press, Tauranga, 1989.

Aveni A., *Empires of Time*, Basic Books, New York, 1989.

Bascom W., *Waves and Beaches: Dynamics of the Ocean Surface*, Doubleday, 1964.

Biodynamic Planting and Sowing, BFG (NZ) Inc.

Brosche P. and Sündermann J. (eds), *Tidal Friction and the Earth's Rotation*, Springer Verlag, New York, 1978.

Brosche P. and Sündermann J. (eds), *Earth's Rotation from Eons to Days*, Springer Verlag, New York, 1990.

Burroughs W.J. (ed), *Weather*, Nature Company, USA, and Reader's Digest, Sydney, 1996.

Calvin W.H., *How the Shaman Stole the Moon*, Bantam, New York, 1991.

Canning J., *Great Disasters*, Octopus, London, 1976

Clark C., *Flood*, Time-Life, Amsterdam, 1983

Clarke-Smith C., *The New Zealand Weather Book*, Whitcoulls, Christchurch, 1978

Cowie C.A., *Floods of New Zealand 1920–1953*, Soil Conservation and Rivers Control Council, 1957.

Davis R. Jr., *Principles of Oceanography*, Addison-Wesley, Reading, Mass.,1973, Chapters 6 and 7.

Duxbury K., *Seastate and Tides*, Stanford, London, 1977.

Eiby G.A., *Earthquakes*, Heinemann, London, 1980.

Folley T., *The Book of The Moon*, Courage Books, 1997.

Holford I., *The Guinness Book of Weather Facts and Feats*, Guinness Publishing, London, 1977.

Hutchings J.W., *Weather and Climate in New Zealand*, A.H. & A.W. Reed, Wellington.

Jones I., *My Meteorological Career*, Crohamhurst Observatory, 1949.

King C., *An Introduction to Oceanography*, McGraw-Hill, New York, 1962, Chapter 6.

Lambert M. and Hartley J., *The Wahine disaster*, A.H. & A.W. Reed, Wllington, 1969.

Lieber A.L., *How The Moon Affects You*, Hastings House, 1996.

Meeus J., *Astronomical Tables of the Sun, Moon and Planets*, Willmann-Bell, Richmond, Va., 1985.

Mitchell-Christie F., *Practical Weather Forecasting*, A.H. & A.W. Reed, Wellington, 1977.

Orser M. *Predicting With Astrology*, Harper & Row, New York, 1977.

Ottewell G., *The Astronomical Calendar*, Astronomical League, Furman University, 1997, 1998, 1999.

Ottewell G., *The Astronomical Companion,* Furman University, Greenville, 1979.

Rosenberg G.D. and Runcorn S.K. (eds) *Growth Rhythms and the History of the Earth's Rotation*, Wiley, New York, 1975.

Thomson P. and O'Brien R. *Weather*, Time-Life, Amsterdam, 1977.

Thun T. *Work on the Land and the Constellations*, Janthron Press, 1977.

Tributsch H., *When The Snakes Awake: Animals and Earthquake Prediction,* MIT Press, Cambridge, Mass., 1982.

Walker L., *Only an Australian*, Walker, 1996.

Watts A., *Instant Weather Forecasting*, Adlard Coles, London, 1968.

index